Basic Colored Pencil

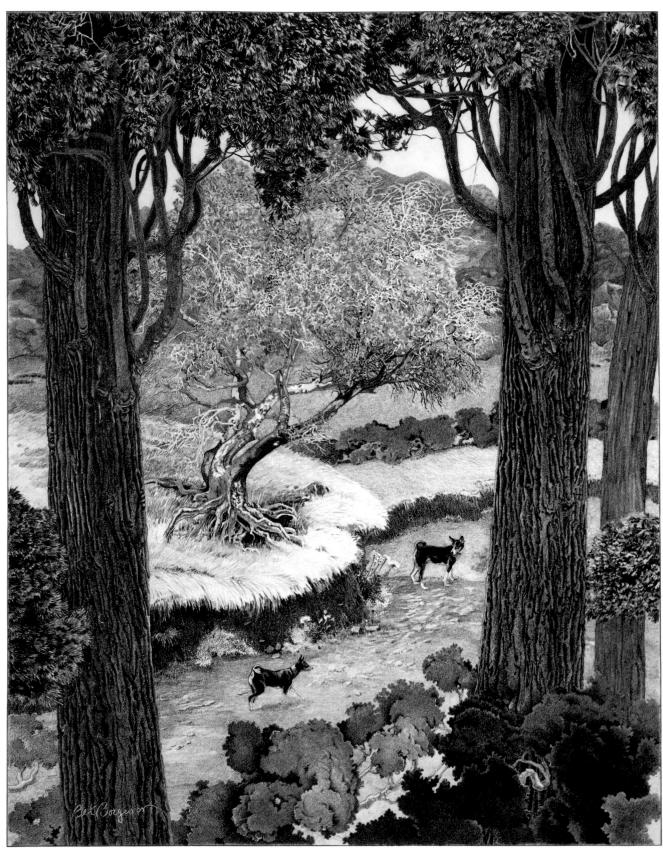

Travelers, colored pencil on two-ply Rising museum board, $27" \times 21"$ (68.6cm $\times 53.3$ cm)

Basic Colored Pencil

BET BORGESON

Interior Photography by Edwin Borgeson

Basic Colored Pencil Techniques. Copyright © 1997 by Bet Borgeson. Printed and bound in China. All rights reserved. No part of this book may be reproduced in any form or by any electronic or mechanical means including information storage and retrieval systems without permission in writing from the publisher, except by a reviewer, who may quote brief passages in a review. Published by North Light Books, an imprint of F&W Publications, Inc., 1507 Dana Avenue, Cincinnati, Ohio 45207. (800) 289-0963. First edition.

Other fine North Light Books are available from your local bookstore, art supply store or direct from the publisher.

01 00 99 98 97 5 4 3 2 1

Library of Congress Cataloging in Publication Data

Borgeson, Bet.

Basic colored pencil techniques / by Bet Borgeson.—1st ed.

p. cm.

Rev. ed. of: Colored pencil fast techniques. 1988.

Includes index.

ISBN 0-89134-736-4

1. Colored pencil drawing—Technique. I. Borgeson, Bet. Colored pencil fast techniques. II. Title.

NC892.B68 1997

741.2'4—dc20

96-32634

CIP

Cover photo by Pamela Monfort Braun, Bronze Photography Edited by Joyce Dolan Designed by Angela Lennert Wilcox

North Light Books are available for sales promotions, premiums and fund-raising use. Special editions or book excerpts can also be created to specification. For details contact: Special Sales Manager, F&W Publications, 1507 Dana Avenue, Cincinnati, Ohio 45207.

I would like to dedicate this book to two longtime and valued friends of my husband and me. Both of them are successful in fields other than art, and neither knows the other. One is Kenneth Peck, an outspoken inventor and entrepreneur, whose strong words of advice have helped move this effort from idea to reality. The other is Arnold J. Hyatt, who introduced me unforgettably to a view of confrontation as a positive rather than a hostile force—and as ultimately the truest economy of action.

ABOUT THE AUTHOR

Bet Borgeson began her formal art education at California's UCLA and, after a move to Oregon, received her art degree from Portland State University. Her original and pioneering technical contributions to the medium of colored pencil have been widely acknowledged, and her artwork has appeared in many art publications and anthologies in the United States and Europe.

Borgeson has also authored *The Colored Pencil* (revised edition) and *Color Drawing Workshop*, the first of these being credited with ushering in a virtual explosion of worldwide interest and enthusiasm for colored pencils as a fine art medium. While continuing to produce her own work, she also conducts several popular workshops each year in selected cities.

to by Edwin Borgeson

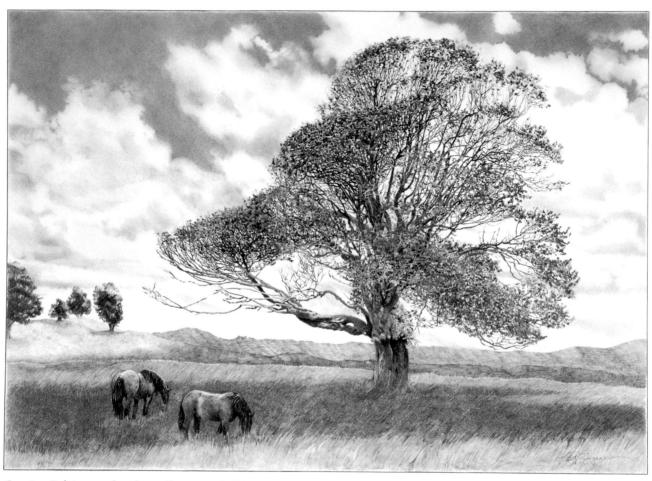

Grazing Belgians, colored pencil on two-ply Rising museum board, $20'' \times 38''$ (50.8cm \times 96.5cm)

TABLE of CONTENTS

INTRODUCTION

PAGE 8

PARTONE

THE BASIC TECHNIQUES

PAGE 10

The Basic Tools

Drawing Surfaces

Basic Tonal Layering

A Two-Layer Approach

A Reconstructed Drawing

Spot Layering Techniques

Juxtaposing Color

Using Line With Tone

Lifting Color

PART TWO

TECHNIQUES TO HANDLE BACKGROUNDS AND OTHER LARGE AREAS

PAGE 60

Begining With Broad Stick Colors

Establishing Large Areas of Color

Broad Stick Colors Combined With Nonmatching Pencils

Single-Layer Techniques

Working to Edges

Injecting Color

Imprimatura Techniques

Gain Complexity With Texture

A Surface-Distressing Technique

Using a White Background

Using a Vignette

Colored Surfaces

Selecting a Palette

Enlisting Other Media

PART THREE

REFINE YOUR WORKING METHODS

PAGE 110

Drawing and Studio Tips

Discovering Hidden Time Traps

INDEX

PAGE 126

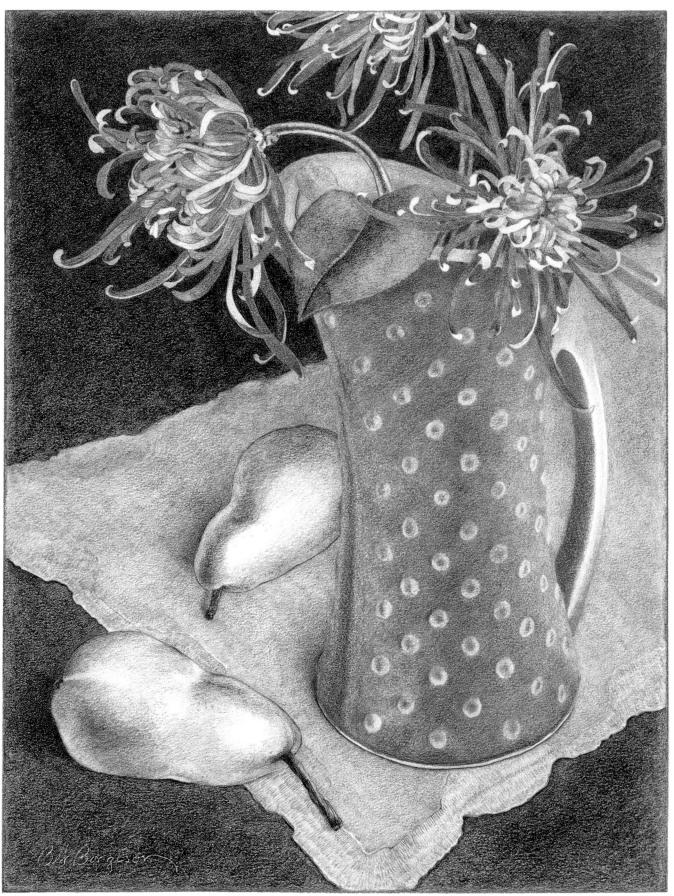

Blue Hobnail Vase, colored pencil on two-ply Rising museum board, $16" \times 12"$ (40.6cm \times 30.5cm). Private collection.

INTRODUCTION

olored pencil is an impressive medium, whether for fine art or illustration, with a range of effects that is often startling. These modest-appearing tools can be made to render the high realism for which they are so well known, or can be used more freely for building passages of luscious color. In either mode, their results can turn a viewer's first skepticism into a mystified appreciation.

In the material that follows, the basic methods for successfully using this medium are fully covered. Also integrated with these methods are many strategies for working faster. For while the popular techniques of layering colors over one another can be painstaking and time-intensive, there are also many excellent ways of achieving spectacular layered-color results with dramatic reductions in time. And these can offer artists of all skill levels increased spontaneity, plus an ability to quickly take on larger and more ambitious projects.

Essentially, this book is offered as a wide-ranging menu of opportunities, ideas and concepts from which to pick and choose, depending on your own temperament, style and drawing needs. It's aimed at being a resource to take into your studio or drawing space, where you can use it, annotate it, and let it help you get on with what is so often a solitary, silent and wonderful task.

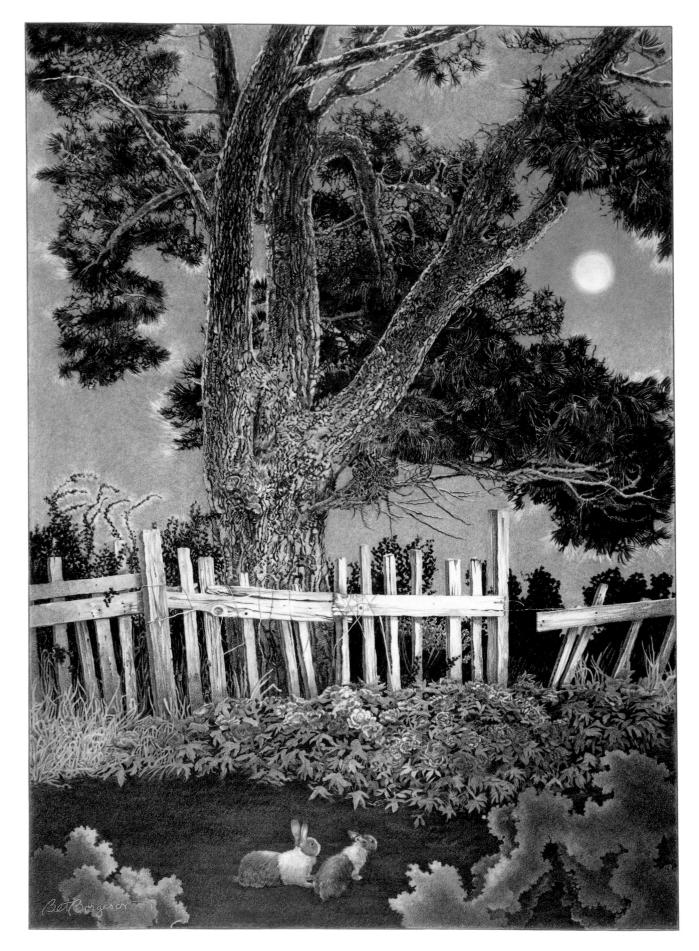

The Basic Techniques

It is in this first part that a pivotal concept—that of combining basic and speed techniques—begins. The tools and materials of the medium are fully discussed. Traditional techniques for expressive color layering are explained and demonstrated. Then a variety of alternative strategies are introduced. These are designed to help you to achieve advanced results with added speed and vitality.

The Basic Tools

Sorting Out Materials

A great advantage of the colored pencil medium is that the tools and equipment needed are simple and inexpensive. Keep this in mind when you next find yourself in the drawing section of a large art supply store, surrounded by row upon row of pencils, colored pencils, and attendant accessories. Beautiful and seductive as all these things may be, your true needs in this medium will remain minimal.

Colored Pencils

There are two kinds of colored pencils: water-soluble, and non-water-soluble. Each kind is manufactured by many companies. While it is convenient to start out with pencils of a single brand, you will eventually want to select—for color and other reasons—from a variety of brands.

If you find yourself beginning with a packaged set of colored pencils, you will soon discover that some of your pencils see almost constant use, while others are never used. Buy all your future pencils from open stock—the racks of individual pencils. Deciding on which colors to buy can be daunting when you are confronted with all the available pencils, adding up to hundreds of color choices. Just remember this: A good beginning palette will basically represent the colors of a traditional twelve-hue color wheel (shown above, right), plus a few neutrals and earths.

Here is a somewhat expanded palette of this kind. It is from the Berol Prismacolor brand, but its colors (with different names) can also be found among other brands:

Yellow

914 Cream 916 Canary Yellow

Yellow-Green

911 Olive Green 912 Apple Green 913 Spring Green 989 Chartreuse

Green

908 Dark Green 909 Grass Green 910 True Green

Blue-Green

905 Aquamarine 907 Peacock Green 1006 Parrot Green

Blue

901 Indigo Blue 903 True Blue 906 Copenhagen Blue

Blue-Violet

904 Light Cerulean Blue 933 Violet Blue

Violet

932 Violet 956 Lilac 996 Black Grape

Red-Violet

930 Magenta 931 Dark Purple 993 Hot Pink 1030 Raspberry

Doc

923 Scarlet Lake 924 Crimson Red

926 Carmine Red

937 Tuscan Red

Red-Orange

921 Pale Vermilion

922 Poppy Red

927 Light Peach

939 Peach

Orange

918 Orange 1032 Pumpkin

Yellow-Orange

917 Sunburst Yellow 1003 Spanish Orange 1034 Goldenrod

Earth Colors

941 Light Umber

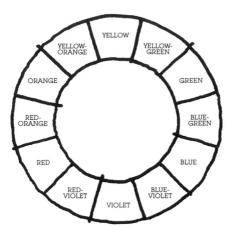

A twelve-hue color wheel

942 Yellow Ochre 943 Burnt Ochre 944 Terra Cotta 948 Sepia 1028 Bronze

Neutral Colors

935 Black 938 White 949 Silver 1054 Warm Grey 50% 1063 Cool Grey 50%

Another consideration when selecting pencil colors is lighfastness. All art media contain some pigments that are less stable, less "permanent" than others. For practice or experimental work with colored pencils, or for illustrations that are to be photographed then filed away, the fading of colors over time is not too great a concern. But if you wish to offer artwork for sale you cannot begin too soon to start educating yourself about color lightfastness. To help with this, some pencil manufacturers now publish and distribute lightfastness ratings for their products.

Sharpeners

It is often surprising to artists unfamiliar with colored pencils how

Colored pencils

The Basic Tools

much sharpening is needed to maintain a pencil's quality of color delivery. A sharp point, for example, can minimize a paper's grain, leading to a more vivid and saturated look. A rounded or blunt point, however, will maximize paper grain, and yield a color that is less intense. Both kinds of points—sharp and dull—may be needed in a single drawing.

Although an electric sharpener may seem a logical choice for all this sharpening, it usually is not. It cannot always provide the point wanted, and it tends to "eat up" pencils. A better choice is a small hand-held sharpener, either of the two-hole aluminum or the single-hole brass kind (as shown right, top). Both have replaceable blades. Sharpeners to avoid are those with built-in containers, an irrelevant feature for a colored pencil artist, or those with riveted-on blades that are not replaceable.

Erasers

A white plastic eraser is used for cleaning *white* areas within and around a colored pencil drawing. But a kneaded eraser is better for lifting away and lightening *colored* areas. A new kneaded eraser (as shown right, bottom) must be hand-kneaded and softened for use. For lifting color with it, an up-and-down rather than a lateral or side-to-side motion is used.

A hand-held portable electric eraser can also be used to lighten applied pencil color. Chief drawbacks for this tool are a high initial cost and a tendency toward too much abrasiveness for some drawing papers.

Frisket Film and Burnishing Tools

Frisket film is a generic term for various low-tack translucent or clear films. In some media these films are routinely used for masking off areas to be protected or preserved. In the colored pencil medium, however, frisket film is used in a different way. It can be made to erase color, by lightly pressing it down on a drawing with variously shaped burnishing tools then lifting it away. It also can be used to draw or mark negatively. Burnishers for this process can be ready-made or home-made, and can be of all sorts of materials, sizes and shapes.

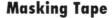

Masking or drafting tape is a familiar item with many uses. In the colored pencil medium it has come to have yet another, and almost indispensable use. Like frisket film, it can lift away color. It can often perform this job on passages of color which are too heavy for frisket film.

A Workable Fixative

With colored pencils there is a special reason for using what is called a workable fixative. Because most colored pencils are wax-based they can, after being applied heavily to a surface, exude excess wax, causing colors to appear slightly veiled. This "wax-bloom," as it is called, shows up more on dark than on light colors. Although it can be easily wiped away with a soft cloth or facial tissue, it will

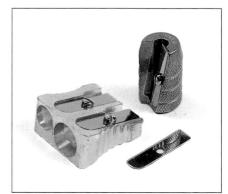

Sharpeners

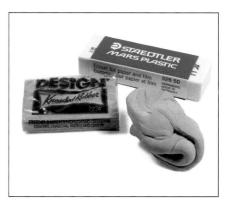

Erasers

return unless the drawing has been sprayed with three or four very light coats of a workable matte fixative. Many such fixatives are available from art supply stores and catalogues. Read labels or product descriptions to determine whether or not a particular brand is suitable for colored pencil work on paper.

Art Stix

Art Stix is the trade name for broadstick versions (as shown right, top) of Berol Prismacolor colored pencils. Some other pencil manufacturers also offer similar versions of their pencils. While these stick-shaped colors look like pastel or Conté crayons, they do not behave like them. They behave, in fact, exactly like colored pencils—but can be used to cover large areas much more swiftly.

Pencil Lengtheners

This handy tool (shown right, center), sometimes called a pencil extender or pencil holder lets you gain additional mileage from very short pencils. Each lengthener is made of a wooden pencil-like shaft and a metal ferrule with a sliding ring for locking in short (but still sharpenable) pencil stubs. Start with two or three of these and plan to add more as you progress.

Pencil Grips

These little accessories (shown right, bottom) made of soft or semi-hard plastic in various shapes, can be particularly useful to colored pencil art-

ists. They go a long way toward fending off hand and finger tiredness during extended sessions of drawing by giving some of your pencils a fatter, more comfortable grip.

A Drawing Board, Space, and Lighting

Your drawing board can be minimal or elaborate, portable or stationary. Commercial drafting tables are roughly table height (30" to 38"), with a work surface adjustable from 0° to 90°. Artists doing commercial or drafting work often sit at higher than ordinary tables on high stools or chairs. When working on art that is to be framed and viewed on a wall, however, it is more practical to sit at a lower table, on a wheeled steno-type chair. This allows rolling backward from time to time for appraising your work from a little distance—a thing not possible when sitting high and only looking down on the work.

Try to arrange an area devoted solely to your work space. Ideally this is a space that can remain intact when not in use—always ready when you are. Not having such a space can inhibit the seizing of spare moments for drawing.

Successfully lighting a work area for colored pencil drawing does not require costly or special lamps. A commonsense approach is to simply arrange lighting that approximates the conditions under which you expect your work to be viewed. Most of the time such settings consist of a mixture of common incandescent light and ambient daylight.

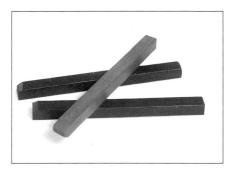

Art Stix

Pencil lengthener

Pencil grips

Drawing Surfaces

Colored pencils can be applied to a wide variety of ordinary or exotic surfaces such as wood, clay, plastic, canvas, or gesso. But the surface preferred by far by most artists is simply that of a good quality, resilient, medium-grained paper.

Seek out paper that is soft, but not so soft that it cannot hold the edge of a sharp, crisp line. Be sure that you test both sides. Your "right" side may be someone else's wrong side. Above all, don't try to judge papers by merely looking at or touching them. The real test lies in drawing on them with your own pencils.

A drawing paper can also contain a built-in speed factor. The choice of one brand of paper over another can actually produce a dramatic difference in the speed of colored pencil work.

Differences in paper speed relate to the way a pencil's color is delivered to a paper's surface. When pencil strokes are applied fairly rapidly to a medium-grained paper, with medium pencil pressure, the pigment is first deposited on the highest ridges or hills of the paper's surface. Covering the paper more thoroughly—filling in the white flecks that are the valleys—requires either using heavy pencil pressure, with its attendant wax buildup, or working the pencil slowly into the valleys with a very sharp point.

Fast working papers speed up this process because they have a somewhat softer and slightly less rigidtoothed surface than other papers. These characteristics make it possible to accomplish very rapid color saturation, even with a dull pencil point and only moderately heavy pencil pressure. These three simplified schematic views show how colored pencil pigment is transferred to paper.

With ordinary mediumgrained papers and moderate pencil pressure, pigment is deposited on the relatively rigid hills of the paper's tooth. This results in a white-flecked appearance that is not always desirable.

To reduce the fleck and gain more color saturation—still with moderate pencil pressure—pigment must be deposited in the paper's valleys with a sharp pencil point.

With a softer, fast-working paper, tonal applications of pigment with moderate pencil pressure compress hills and valleys together. This means that a well-saturated passage of color can be applied rapidly, with no particular need for a sharp point.

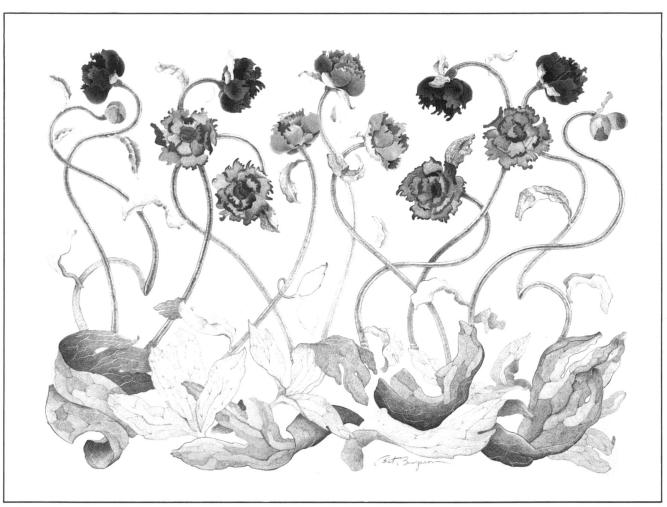

Rising museum board provides a fast-working surface for medium to heavy pencil pressure. White Floral
Colored pencil on Rising
museum board, 32" × 40"
(81.3cm×101.6cm).
Private collection.

Polyester Film—Another Fast Surface Cronaflex—a translucent, neutral pH, polyester tracing film, frosted on both sides—may be the fastest surface of all for colored pencil work. Pencil pigments can be applied either linearly or tonally to its frosted surfaces; they immediately appear dense and saturated. Visible granularity is practically nonexistent, and the finished look with colored pencils is much like that of a painting.

Basic Tonal Layering

Olored pencils are so versatile and so easily manipulated, they can be used in almost any way to suit your temperament and needs. But the way most artists use them is with what is called a tonal layering technique. *Tonal* means pencil strokes applied so close together that they merge into solid areas of color. *Layering* means the stacking up of the semitransparent colors over one another.

Tonal Application

A passage of color applied tonally can have a variety of looks. Each artist develops his or her own way of holding and moving the pencil as it delivers color. The result can seem either loose or controlled. There are other factors too: whether the pencil point is sharp or dull, the paper rough or smooth, and whether the pencil pressure is firm or variable. Even the speed of laying down the color can influence the net result.

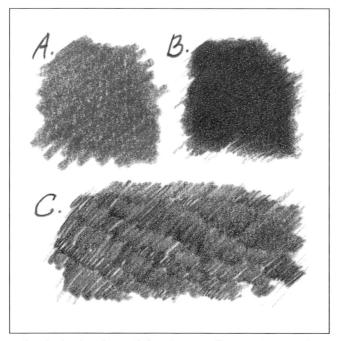

A finished colored pencil drawing usually contains a variety of tonal effects. As examples of this, the first sample (A) was made with a dull or blunted pencil point. In the second sample (B) the point was kept sharp, reducing the appearance of white paper flecks and thus increasing color saturation. In the lower sample (C) direction of pencil strokes was allowed to show for a look of texture and added vitality.

Layering

Here are the four big reasons for layering with colored pencils:

- 1. To reduce the uncomplicated brilliance of single pencil colors. Painters also do this to reduce the harshness of single pigments.
- 2. To mix and arrive at new colors precisely suited to a personal need.
- 3. To modulate color, and to otherwise add dimension, complexity and richness within each color passage.
- 4. To create or change texture by a manipulation of surface.

It is by the layering of semitransparent colors over one another that colored pencils achieve their subtle and nuance-filled color passages. Most of the expressive effects of colored pencils can be achieved with no more than two or three layers. Using more layers than this often leads to an overly muted final color, and to overly time-intensive work.

Ornaments #2
Colored pencil on medium-grained paper, $17'' \times 12''$ (43.2cm \times 30.5cm). Private collection.

The blackness of the cat in this tonal drawing was constructed by layering three colors (937 Tuscan Red, 901 Indigo Blue, 931 Dark Purple) instead of using just one black pencil. Had a single colored pencil been used, only value (light and dark) could have been varied. By using three pencils of different colors to construct black, hue and intensity, as well as value were all varied for a far more expressive result.

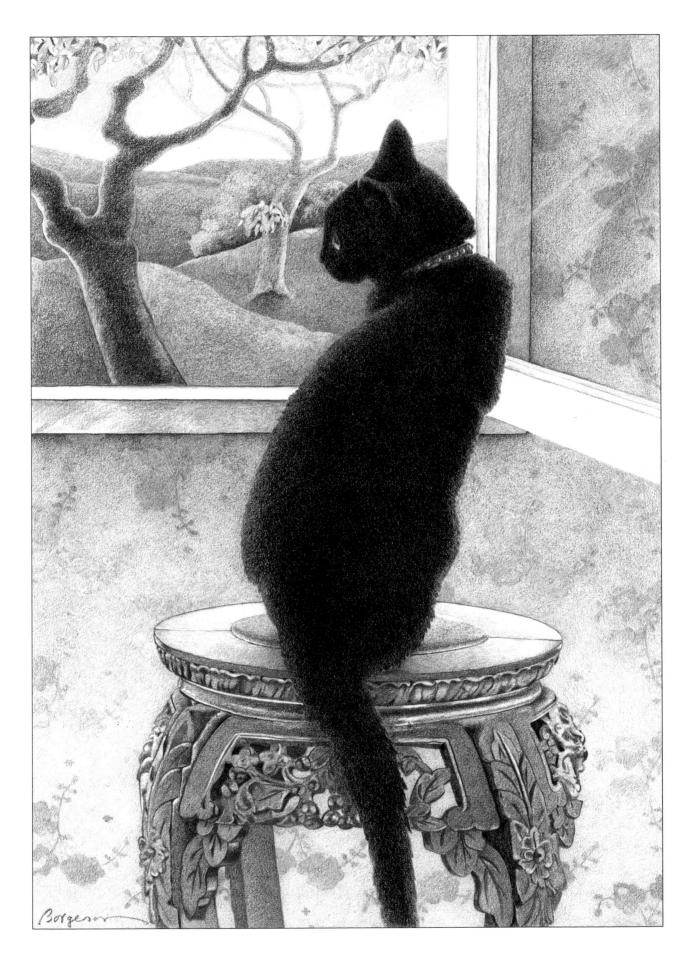

Basic Tonal Layering

A rtists who work tonally with colored pencils usually choose between two great paths: one characterized by texture, the other by an absence of texture.

By texture we mean the granular white flecks that naturally occur when a colored pencil is stroked with varying pressure over a medium-grained paper. This path relies on the built-in semitransparency of the pencils to develop subtle layers of color.

The other path (shown on pages 24 and 25), is often favored by illustrators. It relies on pencil color applied so heavily that no trace of the paper's natural surface remains visible. The colors with this method appear strong and saturated, an effect yielding an opaque and painted look.

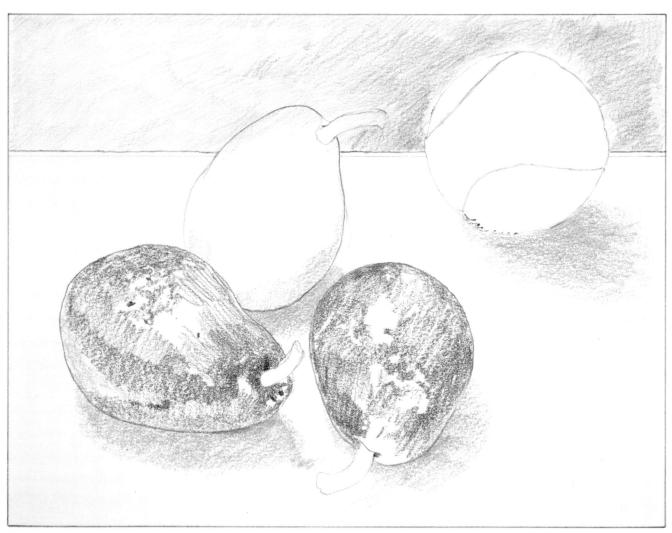

Step One I used a HB graphite pencil to position the red anjou pears and baseball within a rectangular frame. The graphite is shown heavier than necessary, for the sake of photo reproduction. If these guidelines are kept faint, they won't have to be erased later, except in very light colored areas.

We have two tasks with colored pencils: drawing and deliv-

ering color. Sometimes we do these simultaneously, sometimes separately. In this case, all the colors—903 True Blue in the background, 922 Poppy Red on the pears, 942 Yellow Ochre for the shadows—were applied loosely, almost haphazardly, to get some color delivered, but not yet to really draw the forms.

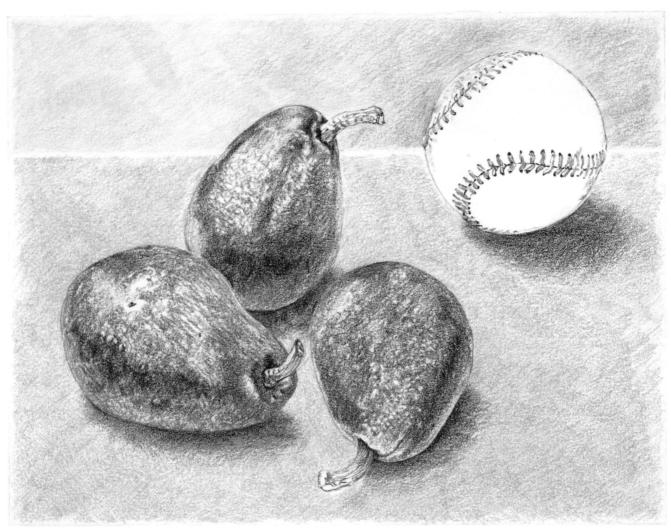

Step Two To begin modeling the rounded forms of the pears, a 931 Dark Purple was used as a first layer on the rear pear, and as a second layer on the other two. This time, the addition of light and dark while layering is an example of drawing and delivering color at the same time. Some 931 Dark Purple was also used to darken the cast shadows.

For the lacing on the baseball, I used a 929 Pink along with a graphite pencil to suggest the tiny holes and seam. Think of graphite as an additional color—perhaps a green of low intensity just before it slips into gray. Graphite also holds a terrific point, and is unparalleled at creating tiny slivers of detail. No-

tice how the form of the ball takes shape by just rendering the pink lacing. Shading the pears performs the same modeling function.

I used some 989 Chartreuse rather loosely over the back-ground blue. This area of negative space has a soft and ambiguous look, so the Chartreuse was applied with changes in value. The tabletop, on the other hand, appears solid, so the values must be kept more evenly flat. A very sharp 1003 Spanish Orange was applied more carefully to the tabletop than the Chartreuse was to the background, closing up and reducing the white flecks of paper grain.

Basic Tonal Layering

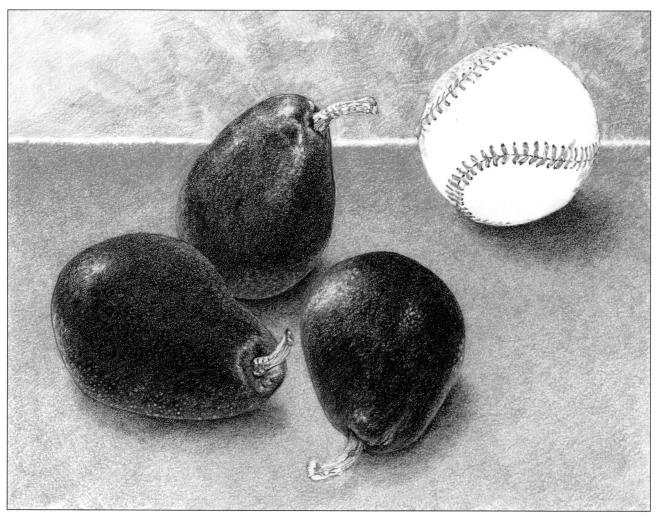

Step Three For visual richness, it was time to begin layering color combinations that express the individuality of each pear, rather than relying on identical "pear colors" for all of them. Toward this end, a 922 Poppy Red and a 937 Tuscan Red were used on all three pears, but in varying amounts. The rear pear received only a light layer of both colors, so it remained cool and stayed firmly placed at the rear. To suggest skin textures, a 1003 Spanish Orange was dotted-in on some areas of the pears, and a 1006 Parrot Green was used at the edge of the left pear to further separate it from the rear pear.

In the background, a third and final layer of 1006 Parrot Green was applied, letting random pencil strokes show here and there, with no attempt to refine the grain.

For the tabletop, however, a sharp 1034 Goldenrod was applied carefully at the back, and blended into the original 1003 Spanish Orange. Notice that a sliver of white paper remains uncovered at the back of the tabletop.

A kneaded eraser was used to lift and adjust some of the 931 Dark Purple in the shadows. A 1034 Goldenrod was then applied—not as a third layer, but only on the small open white flecks of paper in the shadow areas. Simply layering the Goldenrod on top of the Purple would have darkened the shadow too much.

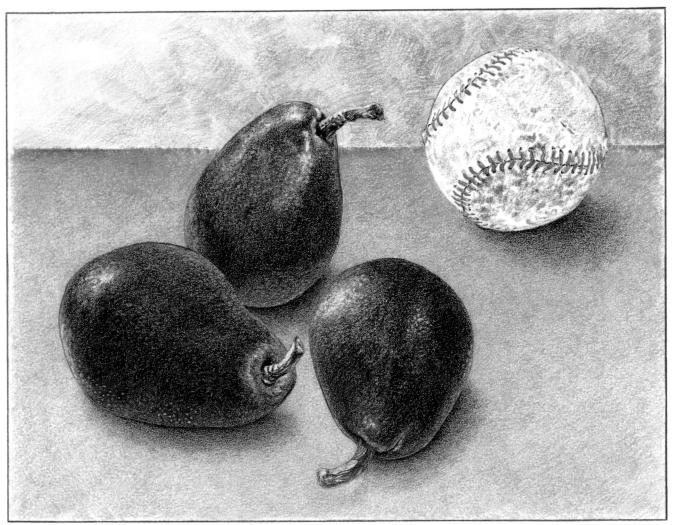

Step Four The last step with colored pencils is usually not one of layering color, but of drawing additional details and adjusting values—the lights and darks. For example, the baseball's lacing and seam were restated more carefully with 929 Pink and graphite, and a 1028 Bronze was used to weather and age it.

To increase the pear's appearance of roundness, a combination of 901 Indigo Blue and 935 Black were used to darken their interior core shadows as well as all the cast shadows, especially the portions just under the objects. A note about black: a black colored pencil only delivers a black with full pencil pressure. Used with less than full pressure, it delivers a gray.

The white strip behind the ball was left open for a color that would serve both as an accent and as a final cool note to help anchor the tabletop edge. For this area I later used a 929 Pink, which seems both more intense and cooler than the adjacent layers of Goldenrod over Spanish Orange.

Red Anjous and Baseball Colored pencil on Rising museum board, 7"×9" (17.8cm×22.9cm).

Heavy Pressure Layering

n these pages are two heavy pressure techniques used for a non-textured appearance. The first of these techniques is the older of the two. The second technique is much less time-intensive.

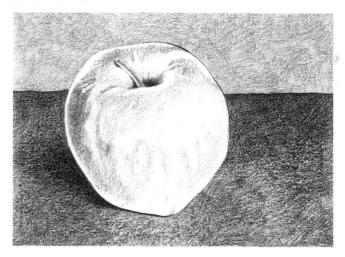

Step One Various pencil colors were applied, using light to medium pressure. Flecks of white paper remain very visible.

Step Two A white pencil was used with heavy pressure over the entire surface. This has altered the colors and greatly reduced the visible white flecks.

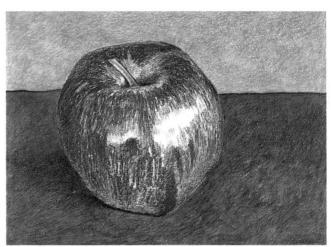

Step Three Another layer of pencil colors was applied over the glazed and whitened surface. This has restored much of the color lost to the white pencil, but some paper texture still shows.

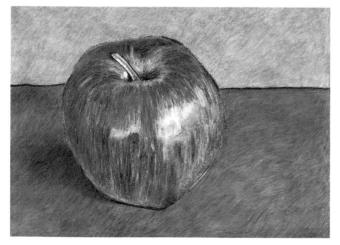

Step Four The white pencil was again used over the entire surface to burnish away any remaining visible paper texture. The surface now has a painterly look.

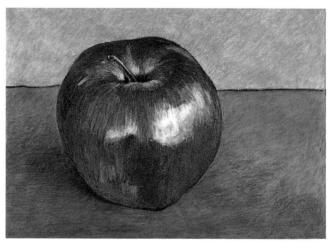

Step Five For a final, bolder result, colors were again applied over the waxy surface to restore lost saturation and to eliminate all traces of paper grain.

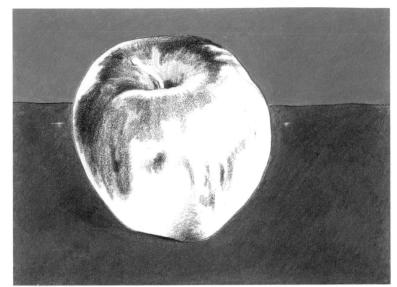

Step One For a second and very much faster method, a soft and pliant surface of Rising museum board was used, and the initial pencil colors were applied firmly to background and tabletop. Colors within the apple were applied with less pressure because they will only subtly mix with the next layer. Paper grain has been significantly reduced right from the beginning. Compare this with the first step in the whitepencil burnishing method.

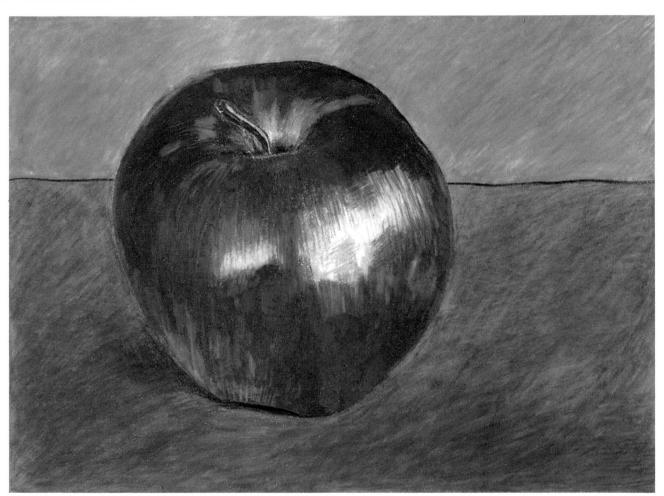

Step Two To complete the drawing, additional colors were firmly applied over the previous colors as needed. White was used in only two limited ways: to lighten the background and to develop and blend highlights. The drawing's painted effect was achieved by simply using firm pencil pressure to reduce paper grain while mixing the colors. Because the finished surface had fewer layers and thus was less waxy, color could in every case be more easily mixed. And because no white burnishing was used, the final colors appear more saturated.

A Two-Layer Approach

A sure way to save time at colored pencil layering is to simply use fewer layers. Imagine, for example, that you are about to begin a drawing and know at the start that you will be limited to no more than two layers of color.

With this kind of limitation, it becomes important to start thinking immediately of how to best use your two layers. Our basic reasons for layering, remember, are to subdue brilliant colors, to mix new colors, to modulate colors, and to develop surface textures. You can do a great deal in all four of these areas with only two layers.

You may also want to remember some color theory that applies to pairs. Mixing two bright colors will reduce the brilliance of both. With analogous colors, the reduction will be very subtle; with near-complementary colors, it will be pronounced. By combining two low-intensity colors, you can attain a look of complexity similar to that achieved by mixing several colors.

Try a two-layer approach wherever you can. It doesn't mean giving up third and fourth layers forever. What it does mean is using your extra layers only for key color passages or particular emphasis, rather than as a quiet thief of your time.

Layering two bright analogous colors (top) results in a subtle reduction in brilliance. Bright near-complementary colors (center) become almost neutral. When two low-intensity colors are layered (bottom), the result always appears to contain more than two colors.

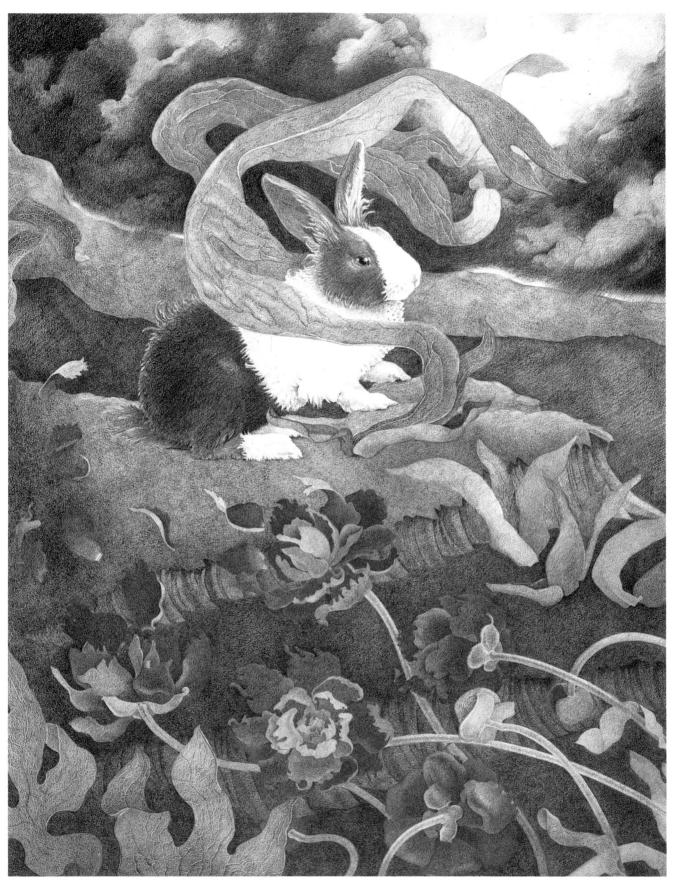

In this drawing, no more than two layers of color were used except for the rabbit's fur and one of the distant hills. Three layers were used for these areas.

Hero, colored pencil on two-ply Strathmore bristol board, $24" \times 19"$ (61.0cm \times 48.3cm). Collection of Mr. and Mrs. Robert P. Cummins, Chicago, Illinois.

A Reconstructed Drawing

This reconstruction of a drawing illustrates a two-layer approach. *Cat and Tulips* (below) was originally drawn with as many as five layers of color in some places. However, I believe I could have achieved almost the same effect with much less color. My plan will be to look carefully at the original layers and from these plan a very similar two-layer version. Also, I would like to brighten the flowers and generally increase the contrast.

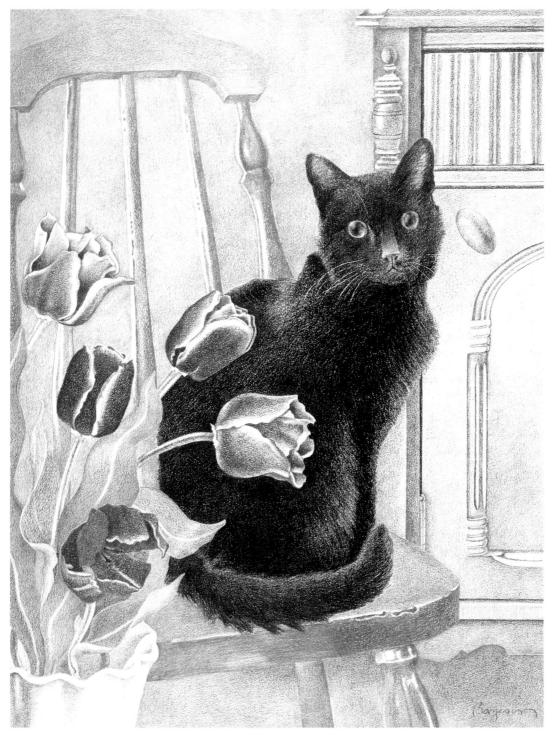

Cat and Tulips
Colored pencil on
two-ply Strathmore
bristol board,
18" × 13½"
(45.7cm × 34.3cm).
Private collection.

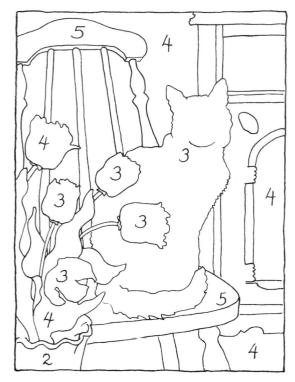

Here are some of the drawing's original color mixtures and the new mixtures planned to replace them:

Background: Original: 931 Dark Purple, 933 Violet Blue, 956 Lilac, and 949 Silver.

New: 931 Dark Purple and 949 Silver. This will retain the silverpurple quality, and the silver alone will the cool the purple.

Chair: Original: 932 Violet, 937 Tuscan Red, 942 Yellow Ochre, 943 Burnt Ochre, and 949 Silver.

New: 943 Burnt Ochre and 956 Lilac. The Burnt Ochre seems closest to the original hue. This light violet will reduce the rawness of the Burnt Ochre and relate the chair's color to the background.

Cabinet: Original: 902 Ultramarine, 903 True Blue, 929 Pink, and 932 Violet.

New: 903 True Blue and 931 Dark Purple. The true blue will work best here, and a single purple can replace the pink and violet.

Cat: Original: 901 Indigo Blue, 931 Dark Purple, and 937 Tuscan Red

New: 901 Indigo Blue and 937 Tuscan Red. The purple will be dropped to reduce the purple cast of the original color scheme.

Flowers: Original: 923 Scarlet Lake, 924 Crimson Red, 930 Magenta, 931 Dark Purple, 937 Tuscan Red, and 949 Silver, used in combinations of three or four layers.

New: 923 Scarlet Lake, 924 Crimson Red, 930 Magenta, and 931 Dark Purple, used in combinations of two layers. Dropping the Tuscan Red and Silver and using no more than two layers will help increase the brightness of this area, as planned.

This sketch maps the approximate number of pencil layers originally used. The extensive color mixing resulted in an overall color scheme of low intensity. This is not in itself an undesirable scheme, and it is an important factor in the drawing's mood. But a low-intensity scheme need not rely solely on the number of layers used. It can, in fact, be more quickly achieved with simple color mixtures that are themselves of low intensity.

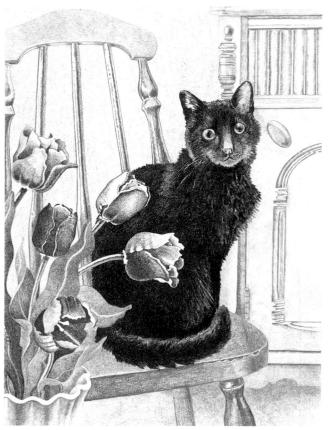

At this stage, the forms and color have been established with one layer on a medium-grained paper similar to that used for the original drawing. In some cases a color or value is incomplete because its completion will depend on a second layer. In the cabinet and flowers, the pencil colors used cannot deliver dark enough values, so these will be firmed up later by alayeral means.

Applying all the first layers of color before moving on to the second layers, as is done here, is a somewhat structured way of drawing. A more common method is the immediate layering of colors as needed. But I think that isolating the layers will better illustrate the concept we are dealing with.

A Reconstructed Drawing

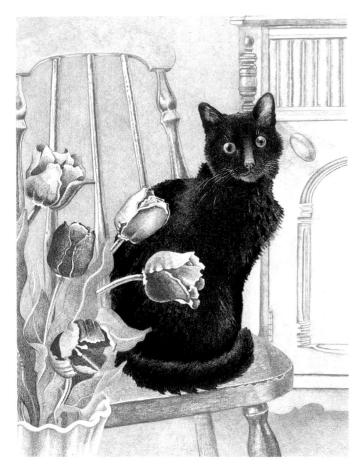

The cat now has both its layers, dark blue and red, and it begins to read as a very black cat. A second layer has been begun on the cabinet, and the background has its silver addition.

To reduce what seemed too purple a cast in the original drawing, the purple was applied lightly this time. If the purple cast were to be duplicated, the purple would have to be applied heavily enough to assert itself more strongly through the silver. Letting the background read as more neutral will, I think, increase the drawing's overall contrast.

Adding light violet to the chair seems to help unify it with its surrounding negative space. The vase and flowers also have their second and final layers of color. If this were a new drawing, rather than a reconstruction, I would probably use a third layer on one or two of the flowers for a bit more color impact.

Except for the cabinet, the drawing has received all its color layers. At this point, close to the finish, it is time to assess its values and details and to make any planned adjustments.

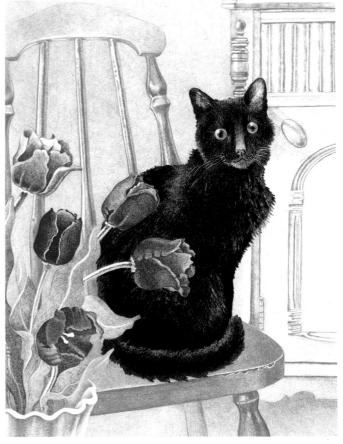

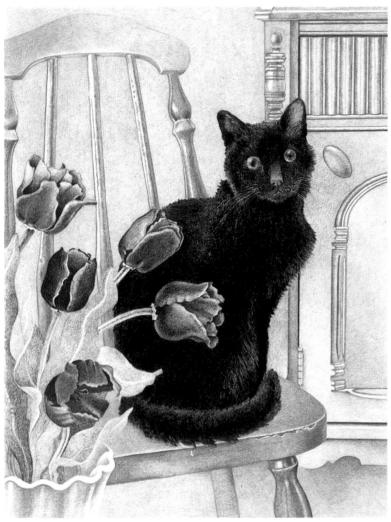

As you can see by comparing this drawing with its original version, two layers can accomplish a great deal in color mixing and complexity. The main drawback of this rigorous approach is that color cannot be as easily and freely modulated as may be desired. In the section that follows, spotlayering will be explored as a fast-working answer to this.

What Is Alayeral? The alayeral parts of a color drawing are those that relate more to drawing itself than to color or layering. This includes all the strokes, blips, hits and other marks that are critical to crisping an edge, darkening a value, or adding a line, but are not layers—that is, they have no direct function in color mixing.

The apple sketched at left contains layered color as well as alayeral work. If we could magically remove all the layered and mixed color to reveal only what is alayeral, our apple would look like the sketch at right.

Spot Layering

The idea behind spot-layering is to use small fragments or bits of color to further modulate a colored passage. You can save a great deal of drawing time by using these selective "spots" of color rather than more extensive layers. This technique works wonderfully well with the already time-saving two-layer approach to colored pencil drawing.

While a two-layer approach permits variations in mixture proportion, in value, and in intensity, it is not well suited to color modulation. And it is in color modulation that spot-layering—whether applied as a bold accent or feathered subtly into an area—comes to the rescue.

Spot-layering is most effective when it also relates to

a firm understanding of what is alayeral (the barest strokes of drawing, but not of color) about our work. The connection here is that seeing alayerally can prepare us for thinking of color itself as a constantly merging and overlapping thing, rather than as applications of formal layers.

As we learn to think of our work in its separate parts—the alayeral, the limited layering, the spot-layering—the process of drawing with colored pencils speeds up dramatically. The bonus in quality this may also bring derives from a new ability to see color not as static mixtures but rather as the dynamic facets of true light's constant changes.

In this drawing no more than two layers (and often only one layer) of pencil color were used anywhere. Spot-layering was used freely, as can be seen in the window sash, wallpaper and dog.

Beauty

Colored pencil on two-ply Strathmore bristol board, 17½" × 12¼" (44.5cm×31.1cm).

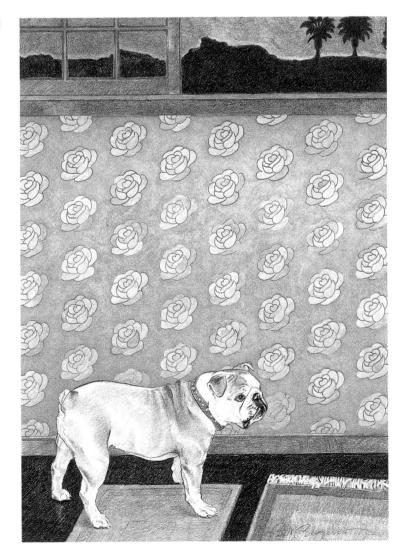

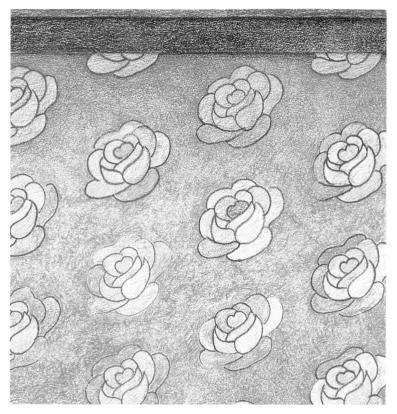

In the upper right section of wallpaper, spot-layering was used with little concern for finesse. It is a fast way of increasing color modulation, and in this case it also offered me an opportunity to restate the animal's boldness of spirit.

The detail below from the same drawing shows a more reserved use of spot-layering to model the dog's form. While the dog was rendered in only one layer of color, I used different pencils to produce that layer. The spot-layered color changes are not as distinct here as in the wallpaper, nor are their edges as visible.

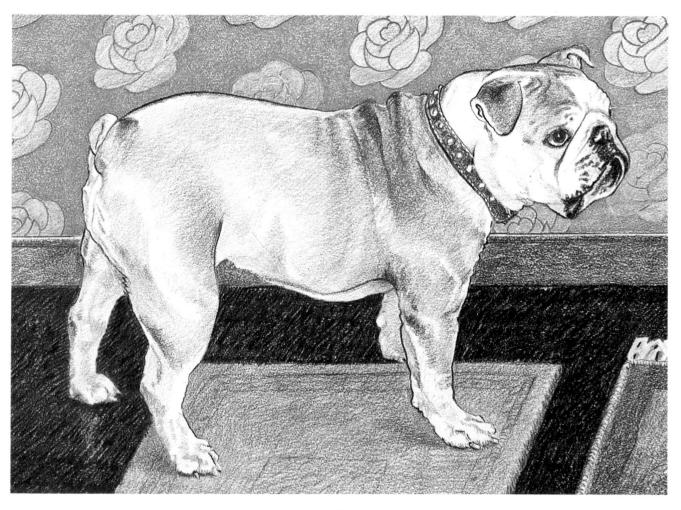

The Basic Techniques

Spot Layering

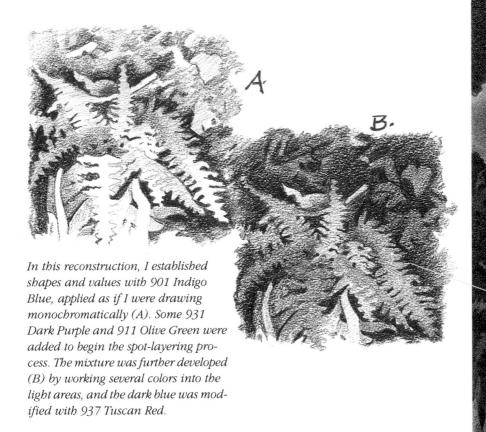

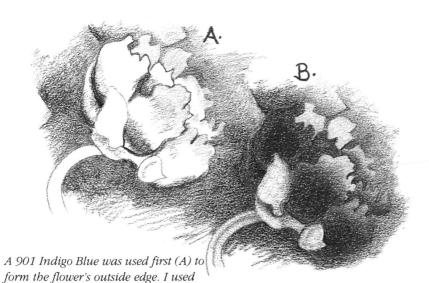

Sanctuary
Colored pencil on three-ply Strathmore bristol board, $18" \times 25"$ $(45.7cm \times 63.5cm)$.

color.

only spots of related color in the flower's interior, as a start toward modeling its form. These areas were then blended together (B) with still another related

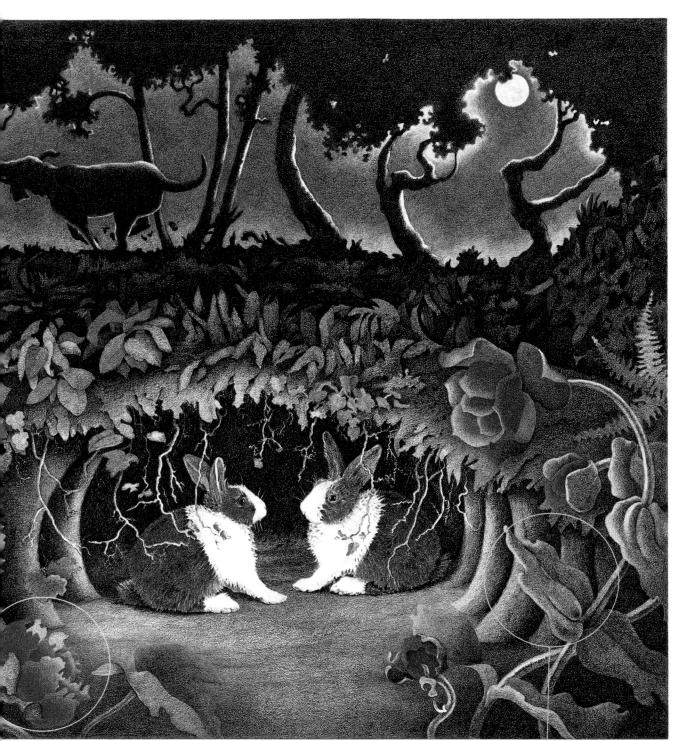

This example, like the others, shows how I used several colors that were not layered over one another but instead were spotted into selected areas, as in the leaf (A). These spots were then knitted together or blended with other colors (B).

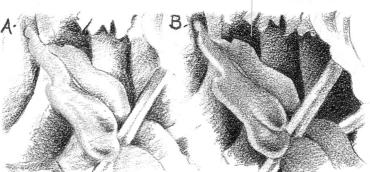

Bold Spot-Layering

S pot-layering can be bold or subtle, depending on your personal style and the needs of the work itself. In this drawing of a bird-of-paradise flower, my idea was to use color quickly and boldly to reinforce the plant's own dramatic nature.

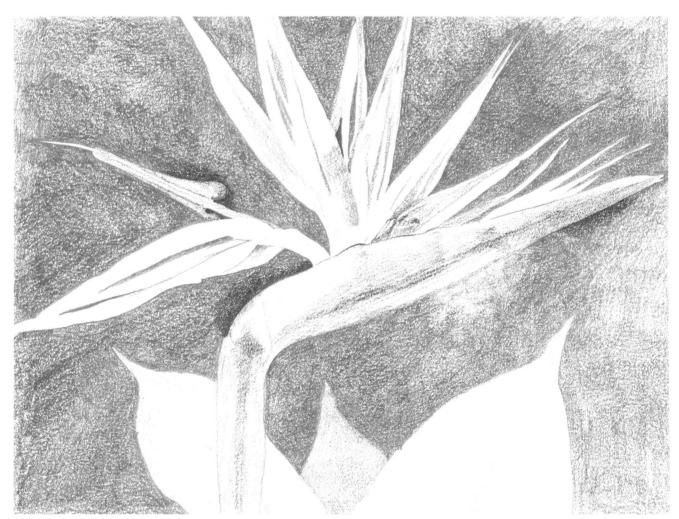

Step One I established my composition with an HB graphite pencil on two-ply Pacifica museum board. Then I tonally applied a layer of 993 Hot Pink to the negative space, working the pencil in all directions. Next, colors were spot-layered onto the flower—917 Sunburst Yellow, 918 Orange, and 903 True Blue on the "tongues." I used 909 Grass Green to begin modeling the form of the "boat." A 917 Sunburst Yellow pencil was used at the very tips of the leaves. A few spots of 932 Violet were added over the pink negative space to remind me of what the final mix here would be.

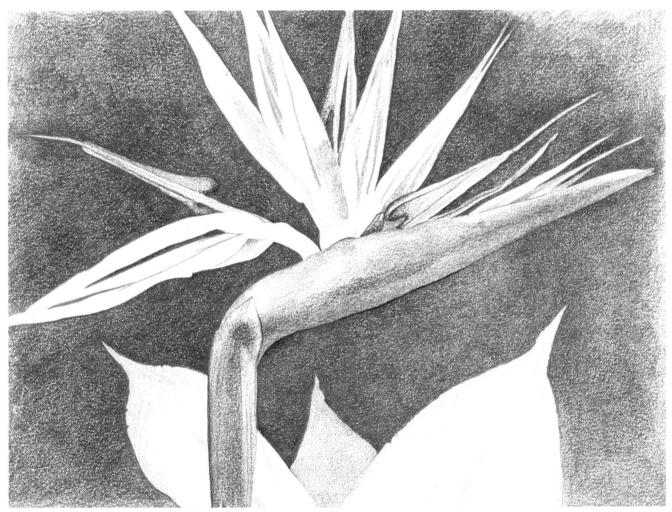

Step Two The plant's "boat" was further modeled with 911 Olive Green. Some 934 Lavender and 903 True Blue were added to approximate the flower's actual local color, and 902 Ultramarine and 910 True Green were added to the blue "tongues." But the most important change was made in the negative space: I vigorously applied a 932 Violet pencil over the pink, allowing much of the original color to show through. I also added some 924 Crimson Red and 903 True Blue, instead of more violet, in selected areas of the background. These bold bursts of color will perform an important function in the next step.

Bold Spot-Layering

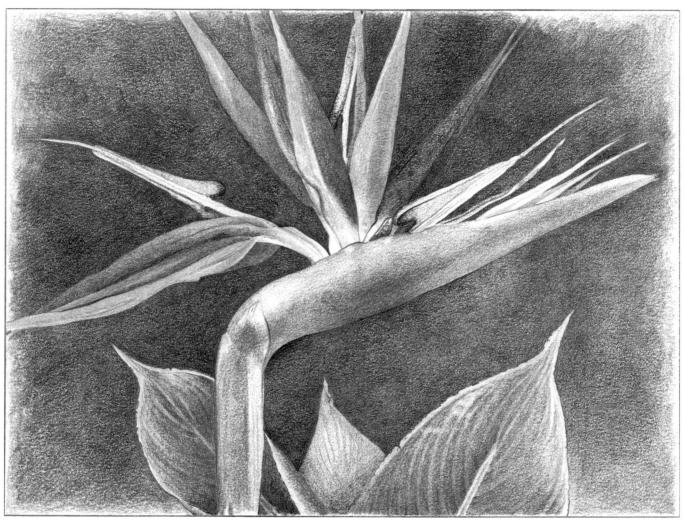

Step Three To finish the drawing, the "tongues" were completed with blended spot-layers of 918 Orange, 923 Scarlet Lake, 993 Hot Pink, and 924 Crimson Red. The "boat" was completed by returning to the original green (909 Grass Green) and blending patches of color together to restate the modeling more emphatically. The leaves were also completed with the same colors used for the "boat," plus some 901 Indigo Blue for a good dark value. Finally, the bursts of color spot-layered into the negative space were better integrated with the surrounding violet. Because they remain bold and separate, rather than being completely blended, they echo the color in the flower itself. This in turn helps the negative space appear atmospheric, making it seem to envelop the flower somewhat instead of lying flat behind it.

Bird-of-Paradise Colored pencil on Pacifica museum board, $7\frac{1}{2}" \times 10"$ (19.1cm×25.4cm). Private collection.

If we could somehow remove all the layered color from Bird-of-Paradise, here is how an alayeral version of it would look.

This shows both alayeral work and spot-layering. The overall layers and the blending layers used to join patches of color have been omitted, but a feeling of modulated color can already be seen in this lively substructure.

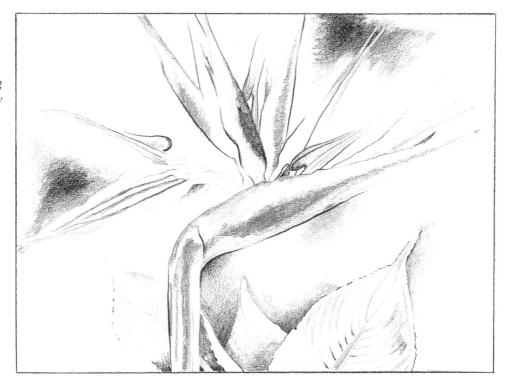

Blended Spot-Layering

F or a portrait to appear credible and lifelike, its flesh colors must be well modulated. This quality can be achieved with only two layers of pencil color when they are combined with blended spot-layering. In this in-

formal portrait, spot-layering was used to represent the planes of the face and to suggest the model's own coloring.

Step One The gestures of head and hair were first established with a spare graphite line on tracing paper. I begin this way because searching for form and the position and proportion of facial features usually includes false starts, and I would rather make erasures on tracing paper than on my final drawing surface. My guidelines were then lightly transferred to a sheet of Stonehenge paper. A soft surface such as Stonehenge is a good choice for colored pencil portraiture, because the subtle blending of flesh colors can be rapidly achieved on it with only light-tomedium pencil pressure.

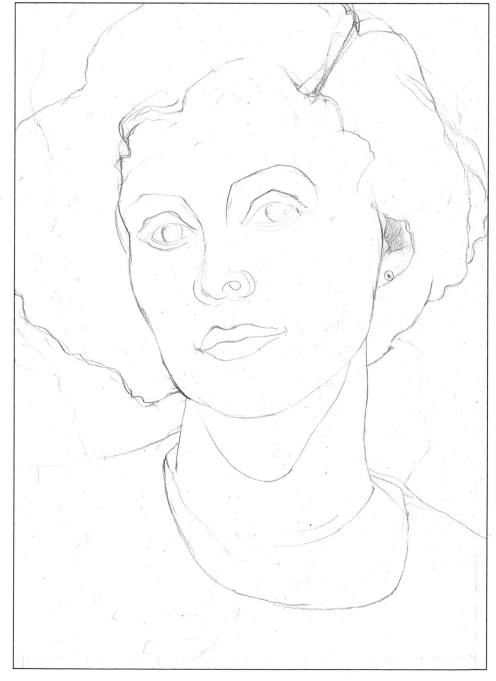

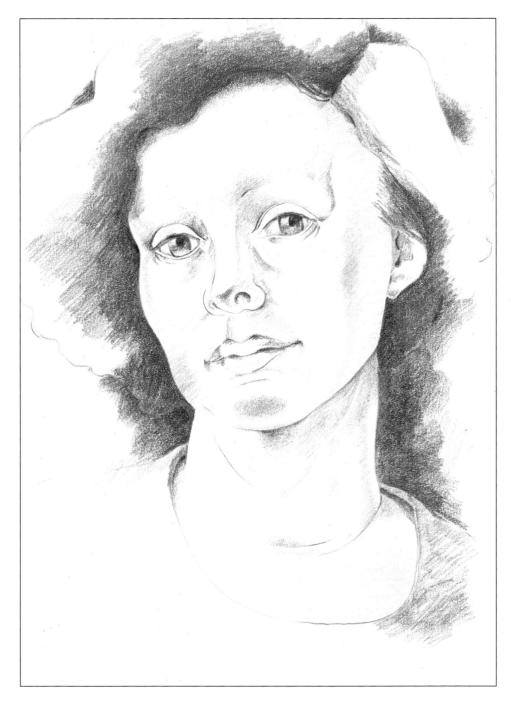

Step Two Spot-layers of color have been laid in but not blended. The colors of the large areas-hair, background, and blouse—were brought in as an environment or surrounding to help with hue and value decisions in the face. These areas don't require much pigment yet, but the colors must be in close proximity to the facial features. Small bits of color—942 Yellow Ochre, 923 Scarlet Lake, 929 Pink, 910 True Green, and 918 Orange—were laid in to begin mixing flesh colors and modeling features. A 932 Violet, used for the head's core shadow, will later be mixed with 931 Dark Purple.

Blended Spot-Layering

Step Three Ordinarily, each spot-layered color would be blended immediately as drawing progressed alla prima, or all at once. The spot-layers have been held back from such mixing to show them more clearly. A 939 Peach was the pencil used most to knit colors together, but the spot-layering colors were sometimes used to smooth transitions. The violet of the core shadows—used to signal plane changes—was mixed with a 931 Dark Purple. I didn't use the violet alone be-

cause it tends to appear hazy

it wouldn't suggest the solidity

I was looking for.

I completed the hair and blouse first so I could better assess what other adjustments seemed necessary. The neck was developed further with the same palette used for the face, to which I added a 906 Copenhagen Blue. This cool color was used to help place the neck securely back under the head. Finally, a few last alayeral adjustments were made. These included darkening the color of the upper eyelids and firming the modeling along the outside contours of the neck and cheeks.

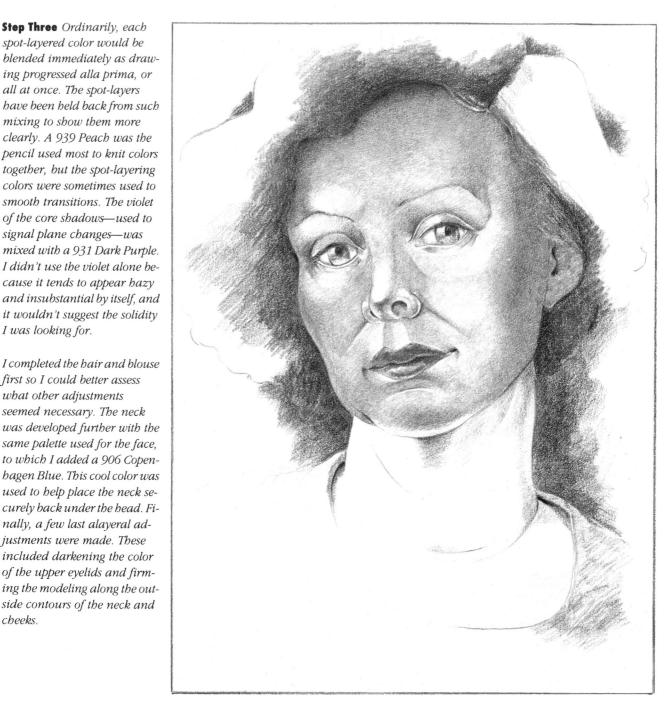

Kate Colored pencil on Stonehenge paper, 11" × 7" (27.9cm × 17.8cm). Private collection.

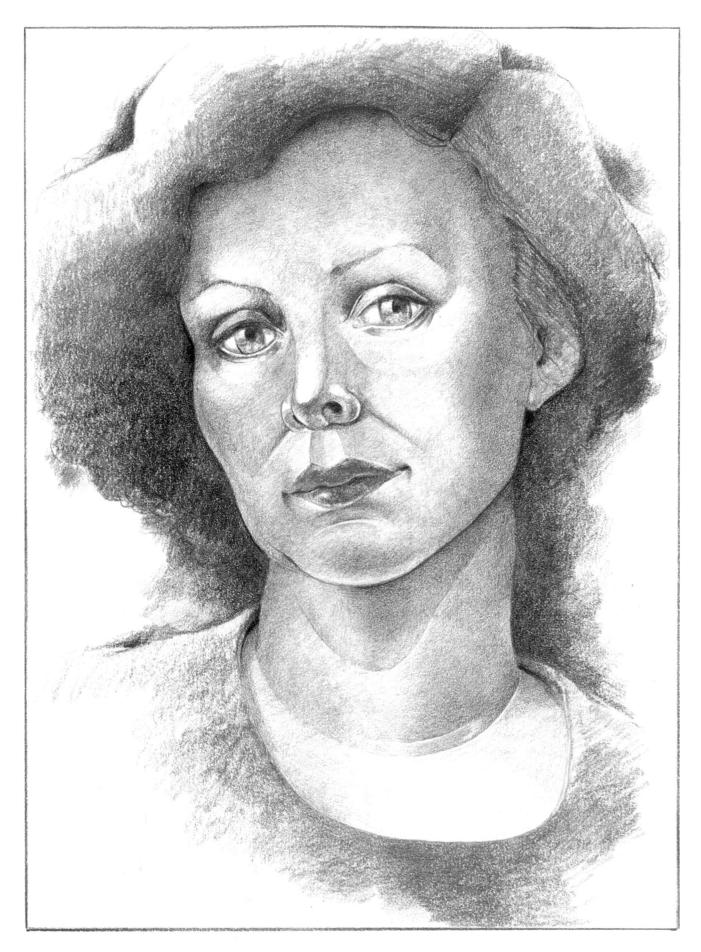

The Basic Techniques

Juxtaposing Color

Juxtaposing color, for our purposes, means arranging areas of color side by side rather than overlaying them. These juxtaposed areas can be mere strokes or larger passages of color. This technique can be a way of achieving color complexity in less time than with layering.

The fastest way to get juxtaposed color results is with single layers, but this kind of mixing also works well with a two-layer approach. Among the possible two-layer arrangements are:

- First layer a single color; second layer juxtaposed colors.
- 2. First layer juxtaposed colors; second layer a single color.
- First layer juxtaposed colors; second layer juxtaposed colors.

Two or more colors can be used in this side-by-side

way, and a single juxtaposed layer may include a number of separate colors that are all somehow related to one another. Reasons for choosing to group certain colors are of course purely personal, but the basic relationships among most color groupings tend to be:

- 1. Analogous colors
- 2. Complementary or near-complementary colors
- 3. All bright colors
- 4. All dull colors
- 5. Colors of contrasting temperature (warm-cool-warm) Much time can be saved by juxtaposing colors as mixtures. But there is an even more important additional benefit to be gained from learning to see and use color in this way: It further promotes an ability to differentiate colors in groupings of seemingly identical objects, whether a bunch of bananas or a field of flowers.

Juxtaposed colors can be used in situations ranging from close detail to broad sweeps. All these sketches (A through D) were made with analogous colors applied side by side.

Within the single petal (A), three colors—917 Sunburst Yellow, 923 Scarlet Lake and 925 Crimson Lake—are juxtaposed side by side. In the group of petals (B), the same three colors were used, plus 924 Crimson Red and 922 Poppy Red. But this time each petal is a different color, and the petals themselves do the juxtaposing. In the two individual flowers (C), a single pencil was used for each (except for a few alayeral details); the juxtaposition of color happens from flower to flower. With the field of flowers (D), all the red through yellow-orange colors are juxtaposed rather than layered, resulting in an optical rather a physical mixture.

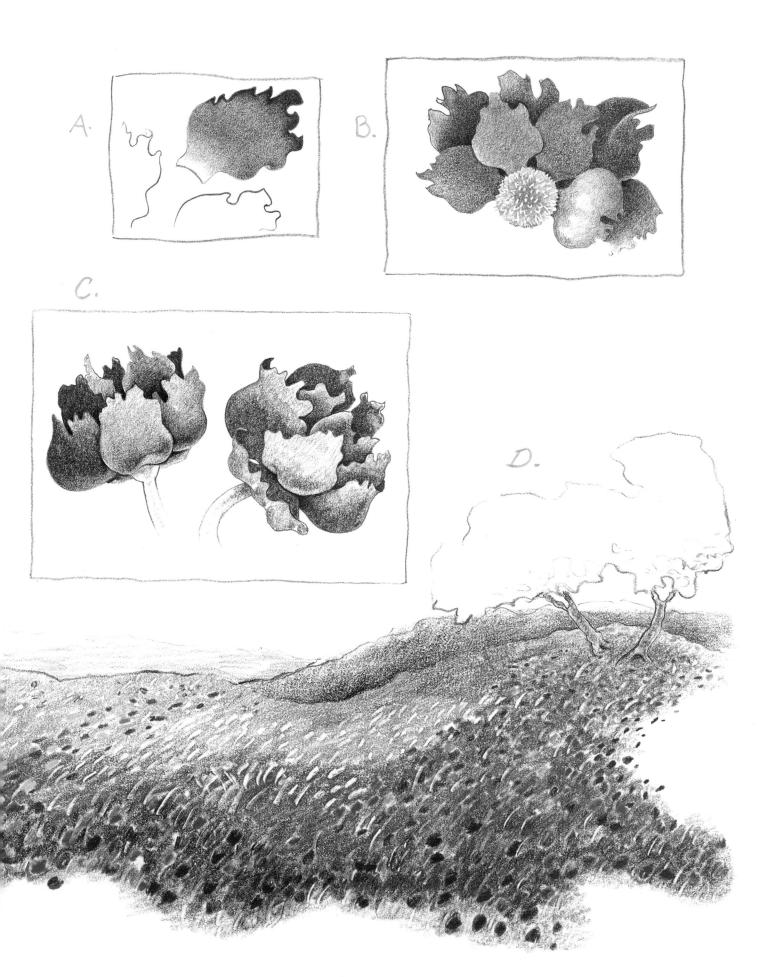

The Basic Techniques

Using Interacting Colors

Olor expressed with a lone colored pencil often appears raw and simplistic. To overcome this drawback of single-pencil layering—while retaining the advantage of its speed—a more complex layer can be created by juxtaposing colors that are related or that interact with one another in some way. Here are a few of the ways in which juxtaposed colors can interact.

Analogous Analogous colors are similar to one another; the term usually refers to adjacent colors on a color wheel. Colored pencils often contain many variations within a hue family, so similar might also refer to colors of the same hue, such as all the reds or all the greens.

Complementary Complementary colors are opposite one another on the color wheel. In practice, we usually deal with near-complementary or nearly opposite colors. Here, the field is a single blue, and the spots are drawn with various orange and yellow-orange pencils.

All Bright Colors In this example, the brilliant white of the paper itself contributes to the "all bright" scheme.

All Dull Colors The word "dull" is not a pejorative in the case of colors; it merely refers to colors of low intensity.

Colors of Contrasting Temperatures

Temperatures of colors may vary depending on their environments. A color's temperature is best assessed in the context of the other colors that you plan to use near it.

Examples of Juxtaposed Color

This drawing contains very little layering. Where layering does occur, it was done in almost every case with a scant spot-layering technique. Most of the color mixing depends instead on the juxtaposition of colors. It is in fact just such a pictorial situation as this—with extensive repetition of similar objects such as the tree leaves—that invites a strategy of juxtaposing colors rather than attempting to layer them.

A.

A scheme of three simple analogous colors plus white was used for the tree foliage (A). In the small reconstruction (B), the redorange wood and the foliage can be seen juxtaposed in a near-complementary color scheme. Most of the colors are single layers, but occasionally a previously applied color was adjusted with another one.

The scheme for the little floral detail was made up of three analogous pencil colors, plus a linear accent of Scarlet Lake (C). In the reconstruction (D), the dark value of the background was also included. Conventional layering was completely bypassed in this passage. Instead, various values of analogous colors were used to suggest the facet-like shapes of the flowers.

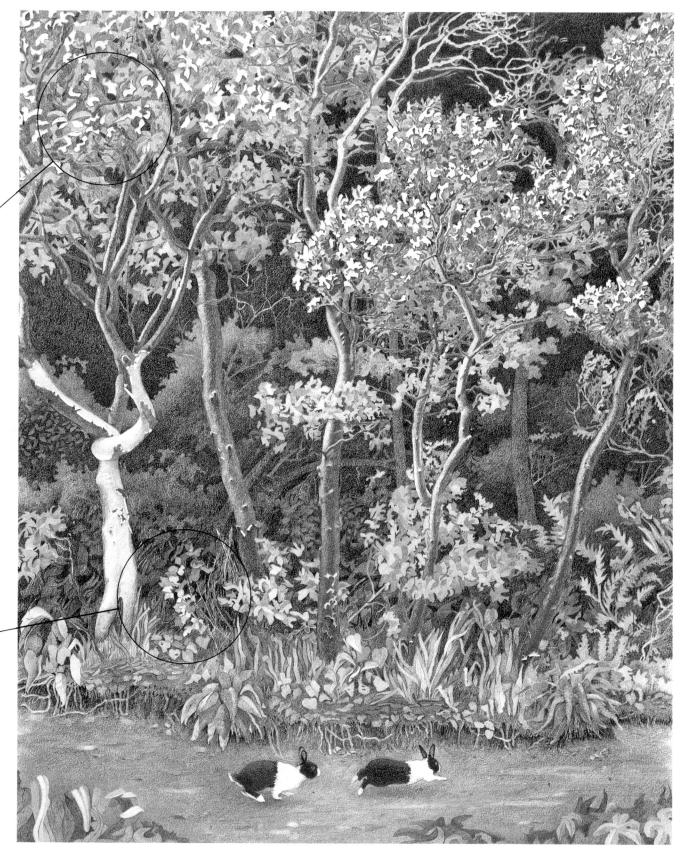

Rabbits and Young Madrones Colored pencil on three-ply Strathmore bristol board, $25\frac{1}{2}" \times 20"$ (64.8cm× 50.8cm). Collection of Mr. and Mrs. John Loewen, Portland, Oregon.

Juxtaposed Color

Juxtaposed color can not only be quickly used to mix and suggest local color, but can also be used as an effective and simple way to achieve depth.

Step One After lightly laying in graphite guidelines, I started drawing the floor with two juxtaposed colors. The cooler of these two colors, a 923 Scarlet Lake, was used toward the back to begin establishing depth, and a warmer 922 Poppy Red was used at the front. Although the floor was done quite swiftly, care was taken to join the colors invisibly. The cat—the only element for which three color layers were planned—was begun with a 901 Indigo Blue.

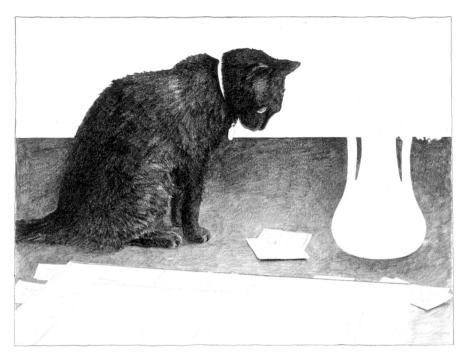

Step Two The molding and plant leaves were begun with analogous colors, 903 True Blue and 905 Aquamarine. The wall was loosely established with a 918 Orange and the flowers with 923 Scarlet Lake. Undersides of the flower petals were drawn by juxtaposing 931 Dark Purple, 934 Lavender, and 956 Lilac petal to petal. The cat was modified with a second layer of 937 Tuscan Red, and the game board was also begun.

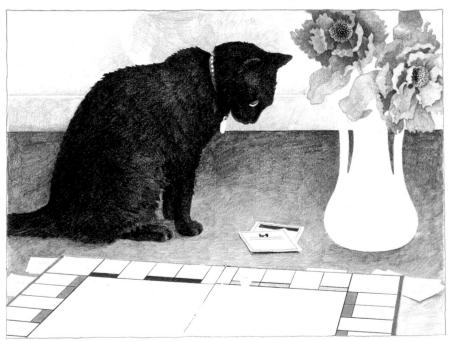

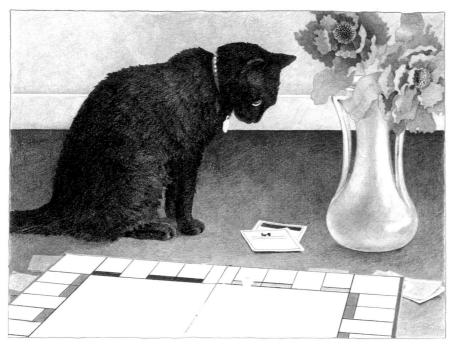

Step Three As a final layer of juxta-posed color for the floor, a 931 Dark Purple was used at the back, blended into a bright 917 Sunburst Yellow at the front. This same warm yellow-orange was also spot-layered into the wall, the molding, and the flower petals. The undersides of the petals were not changed. The vase was modeled in a mostly alayeral fashion, with various light tints of color.

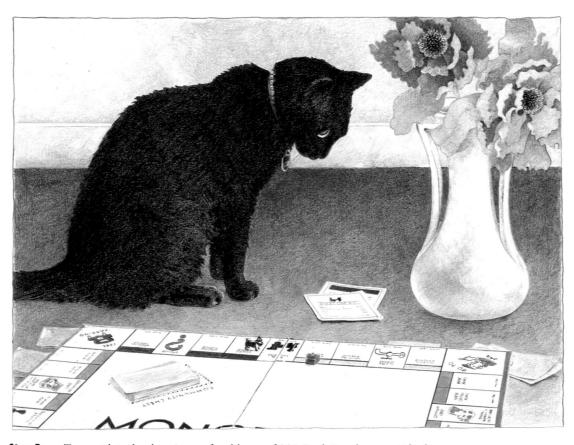

Quiet Game
Colored pencil
on four-ply
Rising museum
board, 12" × 16"
(30.5cm× 40.6cm).

Step Four To complete the drawing, a final layer of 931 Dark Purple was applied to the cat and details were added to the game board. Several alayeral adjustments—almost always needed at this point—were made. Values were darkened where appropriate with colored pencil or lightened with a kneaded eraser. Except for the cat, which was drawn with three layers, none of this drawing's elements contains more than one or two layers, and all the layers were applied with spot-layering or juxtaposed color techniques.

Using Line With Tone

P urely linear drawing is the fastest technique with any pencil, colored or graphite, and it works particularly well with graphite. But with colored pencils, the mixing of colors is all but imperative, and line alone is seldom enough.

There are many opportunities in colored pencil work to profit from line's superior speed. Usually this is done by combining line with tone, which can impart a vigorous texture to other static tonal passages.

The uses of line with tone may be extensive or very spare; this is a matter of personal choice and must be consistent with one's own style. Other ways to incorporate line include using it to abut tonal passages, as in the handling of outside contour edges.

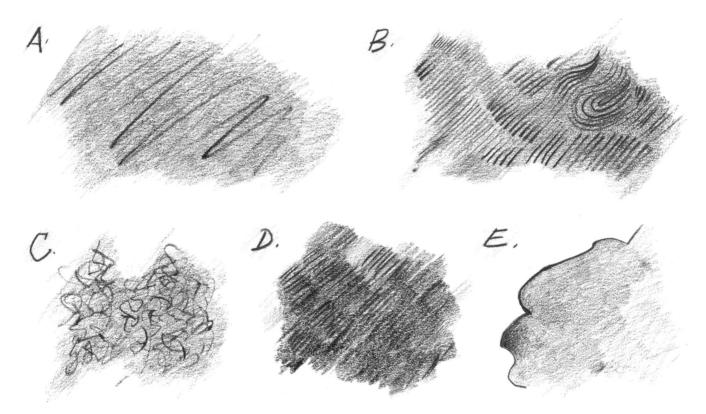

Here are just a few of the numerous ways in which line can work well with tone:

- **A.** A loose, open line cutting across a tone.
- **B.** A controlled line or hatching. The color of the hatching lines can be changed as needed.
- **C.** A personal kind of stroke—in this case, an eccentric calligraphic line.
- **D.** Tone applied over line.
- **E.** A line constructed of two separate colors abutting a tonal area.

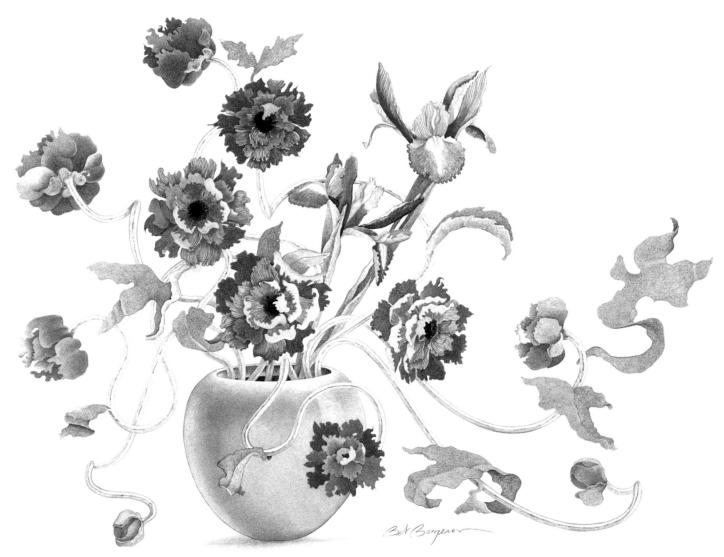

Line was used in two ways in this drawing; the most immediately visible linear work is that in the flower petals. The color mixing here was based on a simple juxtaposition of analogous reds and oranges. Adding line to the tone helps make the petals appear richly contoured and textured.

A more subtle use of line can be seen on the outside contour edges of some of the leaves. This was done to provide a note of hue contrast to what is otherwise only an uncomplicated green.

White Floral #2 Colored pencil on four-ply Rising museum board, $31" \times 38"$ (78.7cm×96.5cm). Private collection.

Lifting Color

Until recently, the colors applied with colored pencils were considered difficult to erase or alter. This often led to inhibition by artists about taking chances or exploring color choices.

Some new techniques are changing this. Instead of erasing—or trying to—with a kneaded eraser (a fine tool for highlighting, but not for heavy-duty work) many artists now use a better approach. They use frisket film or a variety of tacky tapes to lift unwanted color up and away.

And there's more. Using these tacky surfaces makes it possible to draw negatively—to produce light-valued lines and marks—as well as to create new textures in previously established areas of color. Effects such as these, once needing careful planning, can now be easily and spontaneously added to or subtracted from a drawing in progress, or even a finished drawing.

Color Lifting Tools

Frisket film is a generic term for a low-tack, soft, peel-away film. It is widely available clear or translucent, in flat sheets or in rolls. To erase or lighten color with it, the film is peeled from its backing sheet and placed tacky side down over the area to be changed. The film is rubbed *lightly* with a burnishing tool of some kind, and the film then lifted away. This step can be repeated, if necessary, moving to a clean area of film. When not in use, the film's tackiness is best preserved by returning it to its backing sheet.

Everything that can be done with frisket film can also be done with masking tape, and can often be done faster and with greater lifting power. You will probably want to use frisket film for color lifting needing precision and delicacy, and which must be done with good visibility. For lifting extensive color passages, for correcting very dense layers of color, or for the creation of new textures, masking tape might be a better choice.

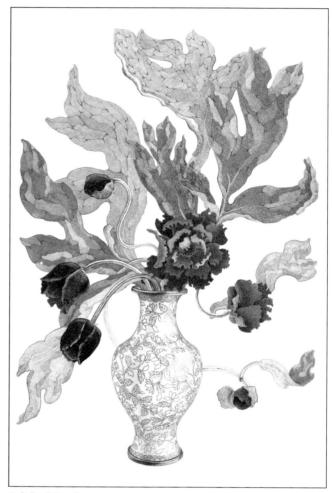

Original Version This drawing began life as a failure. By attempting to stretch the credibility of shapes and colors of leaves, I ended with a drawing that was a loose and spindly aggregate of elements. After a few years of storage, I decided to try improving it with some of the new color lifting techniques.

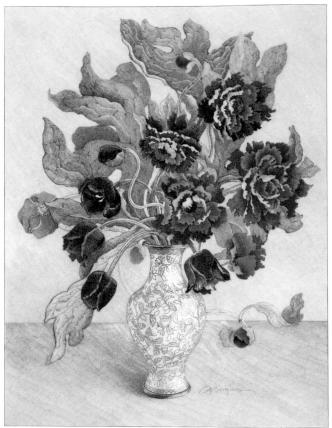

Reworked Version With a combination of frisket film and masking tape, all the leaf color was lifted away. This allows for the application of some new greens, and provides lightened areas for additional flowers and stems. Eleven new flowers or buds were added, as well as a tabletop and a background.

This diagram shows where flowers were added (shaded areas) after underlying color was removed.

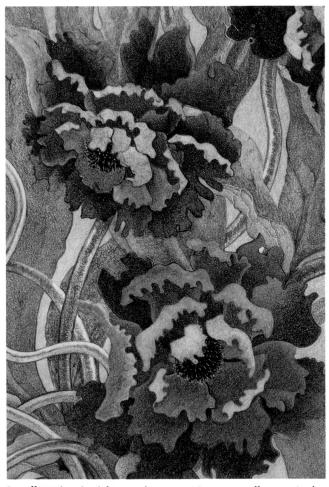

Detail With color lifting techniques, it's not usually practical to strive for a pristine white surface, but is better to settle for a lightly stained surface. These lightened areas can then easily accommodate new color, or read as very light values. In the above detail of the two center flowers, the top flower is the added one. In the light undersides of its petals, the original faint leaf color stain acts as acceptable variations in lightness.

Lifting Color: Two Methods

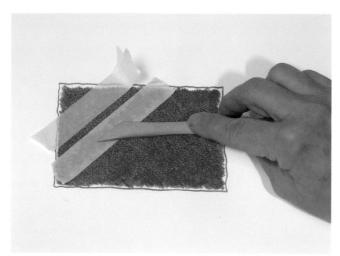

Using Masking Tape Small pieces of masking tape are positioned over an area to be lifted. Masking tape is especially tacky, so additional care should be taken when positioning it. Any accidental patting may cause undesirable color lifts. The burnishing tool shown here is an inexpensive wooden modeling tool. Its wide nib is perfect for lifting large areas.

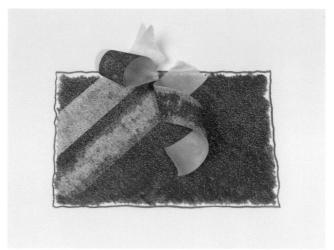

Both pieces of tape have now been carefully pulled away, revealing two kinds of lifts: the top, straight-edged lift was achieved by burnishing completely to the edge of the tape; the ragged edge below it was achieved by burnishing less completely.

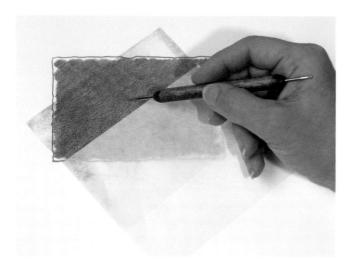

Using Frisket Film A small piece of film is peeled from its backing sheet and repositioned to partly expose some of its tacky surface. It is then placed tacky side down on the area to be erased, textured or drawn on. Patting or pressing the film into place should be avoided because unexpected lifts of color could occur. The kind of burnishing tool used will greatly affect the result. Shown here is a double ball stylus. It has a polished metal ball-tip on each end and will produce lines or marks.

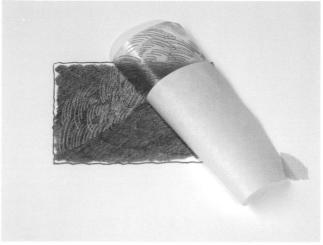

After drawing marks on the frisket film with the stylus, the film is pulled back. The light-valued marks on the sample shown are the result of lifting color. The lifted color itself can be seen on the tacky side of the frisket film.

Lifting Color

M ost of the time, color lifting techniques are hardworking and unobtrusive. You can use them regularly without a great deal of planning, relying on the natural freedom they allow in our work.

But there are also situations when these modest techniques can be called upon to do more spectacular things. At times like this, our new abilities at lifting color can seem almost magic. Here is an example.

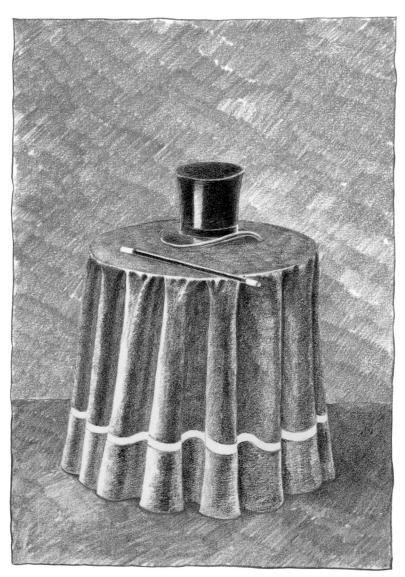

Step One This colored pencil drawing obviously needed some big changes. It needed more drama in its overall color scheme, and more color complexity throughout. But even a more serious flaw was its weak and isolated center-of-interest—the magician's hat and cane—placed squarely in too large an environment. Before the development of modern color lifting techniques these problems might have seemed too enormous, and beyond correction.

Lifting Color

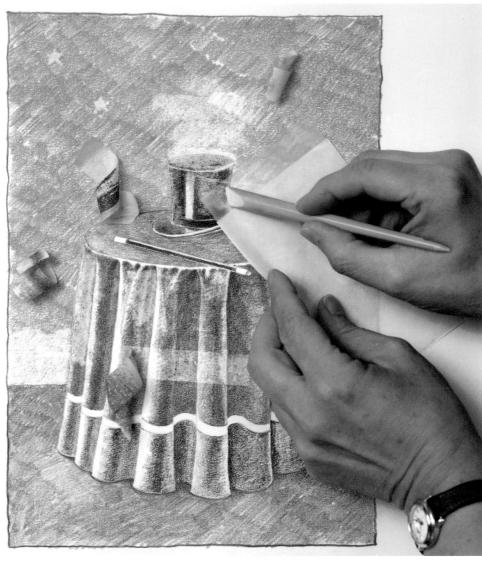

Step Two As a beginning, the hat and some of the background were lifted away, using frisket film, masking tape, and the medium-wide burnisher shown. Bits and pieces of tape remain for possible reuse after beginning the erasure of some of the tablecloth and lower left corner of the background. Notice the beginning of stars in the upper left corner. These were drawn negatively by lifting out star shapes with frisket film and a pointed burnisher.

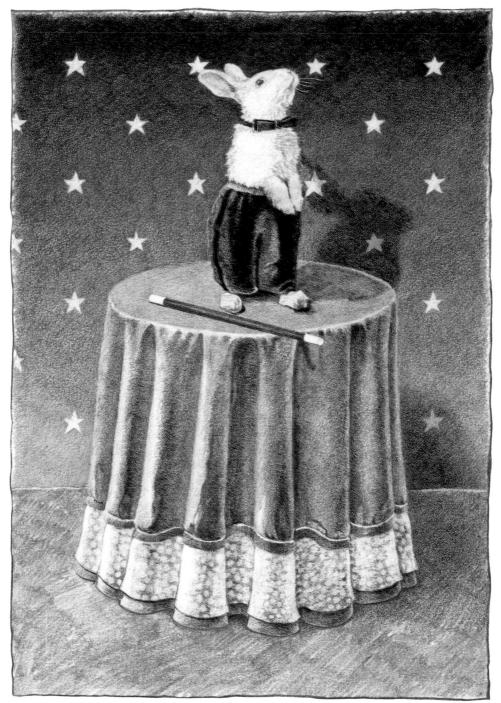

Step Three To complete the changes the background color was lifted to a light value that can still be seen in the stars. Then new and more complex colors were applied. Almost all the colors of the tablecloth and cane were removed to accommodate a new white ruffle, red ribbon and red cane.

Finally, to correct the center-of-interest problem, enough of the dark hat was lifted to allow the white rabbit to take its place. Some of the hat colors can still be seen faintly in the slightly shaded rabbit's paws.

Techniques to Handle Backgrounds and Other Large Areas

The prospect of covering large surfaces with only the point of a pencil is undoubtedly the single most compelling reason why colored pencil work is often of small dimensions. In Part Two we will discuss a number of strategies and techniques related to eliminating this problem while at the same time creating rich and subtle color.

Beginning With Broad Stick Colors

In colored pencil, as in all pencil work, the handling of backgrounds and other large areas is always in danger of getting short shrift. Covering large areas of a surface with a small pencil point is a tedious task. One response to this is to apply background too hastily. Another is a hesitance to attempt work beyond small dimensions.

With colored pencils, however, there are some techniques and strategies that can drastically reduce the time needed to successfully handle large areas.

The simplest and most straightforward way of dealing with large and relatively simple areas is with the broad stick versions of colored pencil pigments now offered by some colored pencil makers. These sticks can be used to lay in a first application of color very rapidly. A sharpened colored pencil can then be used for those places where the stick is too large and to further smooth out the layer applied with the stick if necessary. It is a swift process and can of course be used for areas of positive as well as negative space.

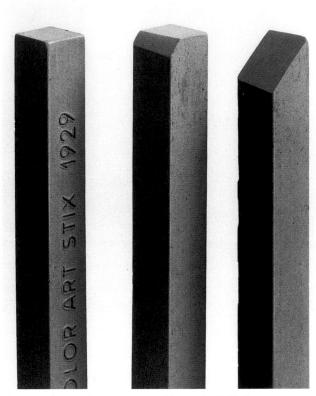

Prismacolor Art Stix are crayonlike sticks (left) that correspond in color to Prismacolor colored pencils. If you want to use them to cleanly deliver a flat application of color, first bevel the tip slightly (center). This flat bevel is made with a firm back-and-forth motion on a piece of scratch paper; hold the stick as it will be held for drawing and take care not to round its edges. The stick at right shows the more extreme bevel developed by contact with the drawing surface.

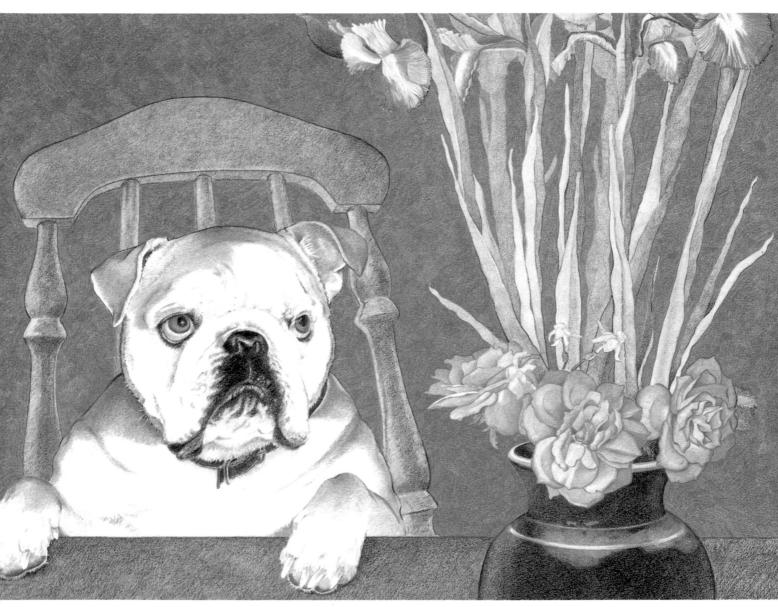

In this drawing, the colors of the background, the tabletop, and parts of the vase and chair were first laid down with Prismacolor Art Stix. Using these pigment sticks for a first layer often results in a texture that can be refined with a colored pencil or overridden by a new texture made with an added layer of colored pencil. The latter method was used in this drawing.

Good Girl Colored pencil on three-ply Strathmore bristol board, 17½" × 24½" (44.5cm× 62.2cm). Private collection.

Establishing Large Areas of Color

T he broad stick versions of colored pencils can be used for completed single layers or as first layers to be covered or modified later. They can also be superimposed on one another. Broad sticks will be used here as a means of delivering preliminary color to just the large areas of a drawing.

To deliver a consistent tone with a minimum of dark streaks, I hold the colored stick between thumb and fingers as shown and work standing at a near-vertical board. You will soon develop a grasp and method that are right for you. The important thing is that the stick's flat surface remain squarely on the bottom, against the paper surface. The stick is run back and forth in the area to be covered, with a motion similar to that of ironing fabric. Practice holding the stick's bevel flat, not letting it rock from side to side.

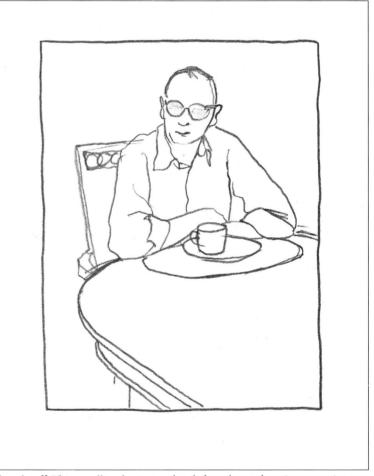

Thumbnail This small preliminary sketch for a large drawing contains two areas that are both large and free of complexity; the table area and the background. It is in situations such as this that using broad color sticks can reduce color application time from hours to minutes.

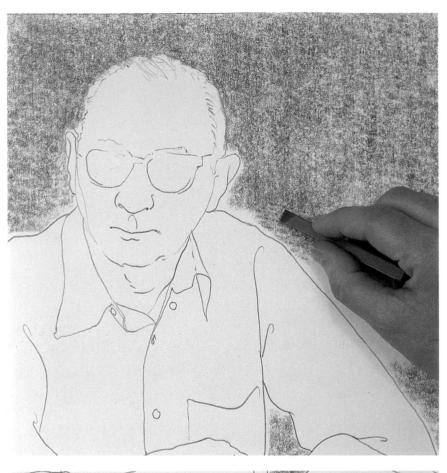

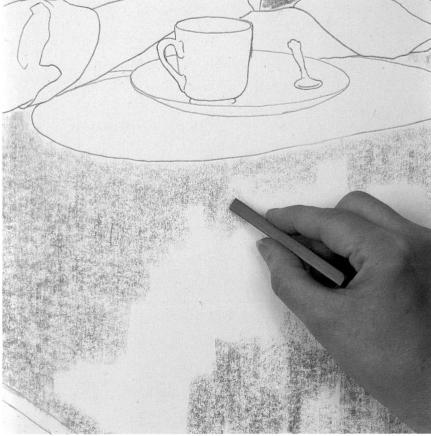

Step One After the drawing was blocked in with graphite, a 1926 Carmine Red Prismacolor Art Stix (top) and a 1912 Apple Green Art Stix (bottom) were used to apply color in the large areas. These two colors match the Carmine Red and Apple Green of Prismacolor pencils. The paper is Stonehenge, which is a good surface for portraiture and also for minimizing the texture that tends to develop with any broad medium.

Notice in the illustration at left how the red runs over the line of the hair. Since the hair will be darker than the red background, the runover will not matter. The green at right, on the other hand, gives a wide berth to the placemat, which will be of a lighter color. The green will be brought to its final edge here with the point of a colored pencil.

For this drawing, I am keeping the values relatively unchanged. Values can be lightened or darkened somewhat with Art Stix, but when used flatly they don't have as wide a value range as the corresponding pencils.

Establishing Large Areas of Color

Step Two Developing color with Art Stix is usually a two-step process. The stick is first used to quickly apply a layer of color, then a pencil is used to finish the layer.

In this case, I used corresponding pencil colors to refine the stick texture and to finish bringing color to some of the edges. I don't consider this pencil work a separate layer, but rather a smoothing out of any mottled or light/dark areas resulting from the stick.

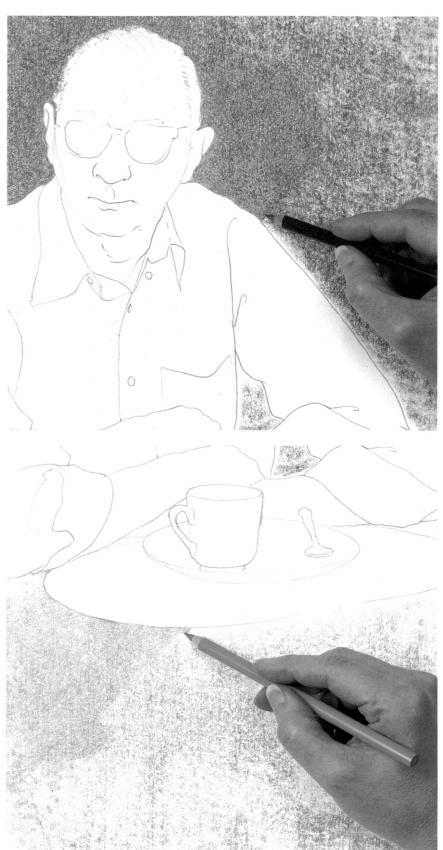

66

Basic Colored Pencil Techniques

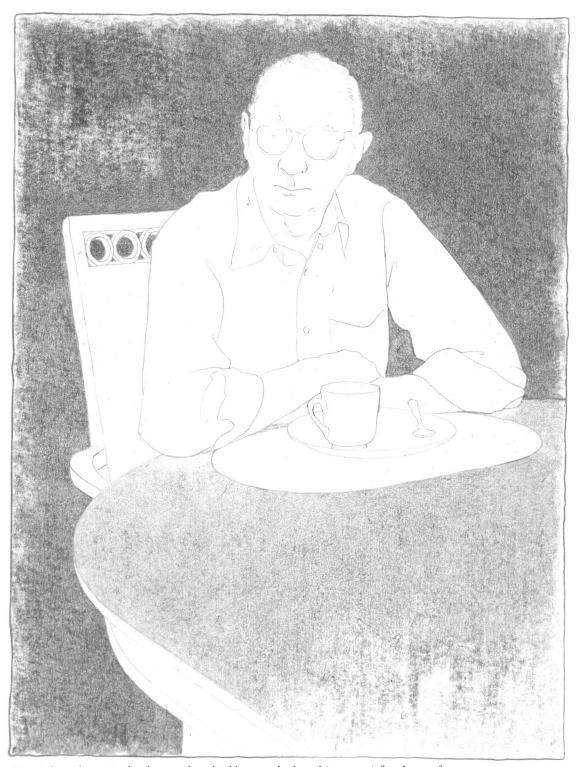

Here is how the entire background and table areas look at this stage. A first layer of Art Stix combined with corresponding Prismacolor pencils has been rapidly completed and is ready for any additional color work.

Note the texture. Where pencil color has been added, the surface is still nubby, but it appears refined compared with areas where no pencil was used, as in the lower right area of the table. Here the texture was deliberately allowed to show as a way of opening up the composition or relaxing the outside edges of the drawing. This area would probably not receive any more color. How much you should refine an Art Stix application—as with all color work—will finally depend on your personal aesthetics and needs.

Broad Stick Colors Combined With Nonmatching Pencils

By using nonmatching colored pencils to refine broad sticks, a complex juxtaposed color layer can be quickly created. This can often serve as a final layer; no additional work is needed.

Imagine this to be part of a much larger drawing. As a first step I applied Art Stix in the usual way, but with this difference: Because I wanted to maximize the white flecks of paper in the background, then use a very visible contrasting colored pencil to refine that area, I selected a waxy stick—1902 Ultramarine. This was applied in various directions. For the tabletop, I chose a less waxy 1931 Purple and applied it more carefully for a tighter grain.

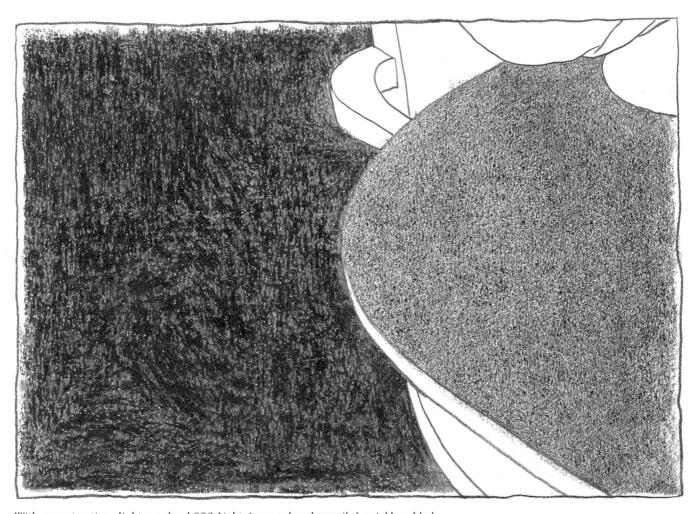

With a contrasting, lighter-valued 992 Light Aqua colored pencil, I quickly added color into the larger white flecks. Surprisingly, this process need not take long to complete, but how far to go with it must remain a matter of personal choice.

The salt-and-pepper mixed-value effect in the background helps to suggest some depth. However, the near-matching value of the 937 Tuscan Red used for refining the purple tabletop helps establish it as a solid plane.

Single-Layer Techniques

A way of handling large areas of color in a drawing is with a single layer of color. The problem with this is that such single layers often tend to be too bright and somewhat simplistic in appearance. Colored pencil layering is in fact generally aimed at avoiding these very pitfalls.

But there are at least three ways of successfully overcoming the disadvantages of single layering. The first is by using the muted effects of low-intensity colors. The second is by juxtaposing colors. And the third is by using an achromatic color, such as gray.

As a start toward looking more closely at each of these three options, let's very briefly review what is meant by color intensity.

Color Intensity

Intensity denotes a color's degree of purity, or saturation. It is one of the three dimensions of color, the other two being hue (a color's identity) and value (how light or dark it is).

Low-intensity colors have been diluted—in manufacture or at the time of their use. This dilution can be achieved by combining them with other colors or with neutrals (black, gray or white).

For our purposes, a colored pencil of low intensity can be thought of as containing a color already mixed with another. Using it is like using two or more pencils combined into one.

Working With Low-Intensity Colors

The colors of large areas are important to any composition. Therefore, it always makes good sense to plan color schemes that take these large areas into account.

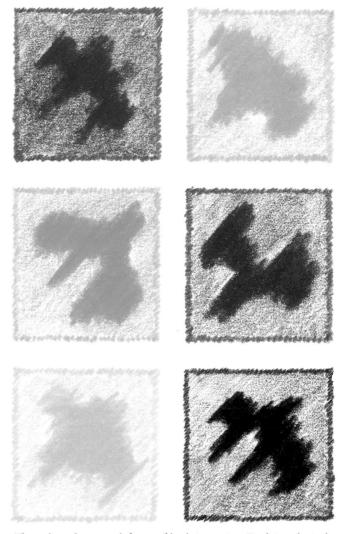

The colors shown at left are of high intensity. Each is relatively pure and saturated. The colors at right are of weaker or lower intensity but are of the same hue families.

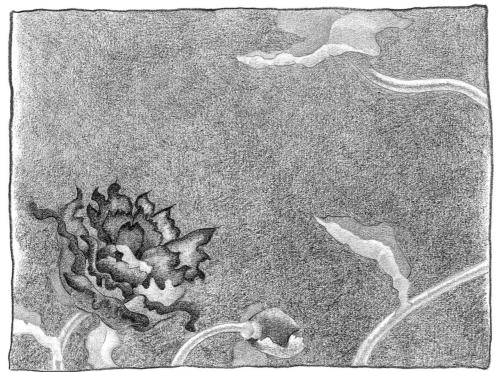

A 948 Sepia pencil—a very low-intensity yellow-orange—applied in a single layer was used in two different ways to indicate negative space. In the top illustration, the layer was applied as an unmodulated middle value. The same pencil was also used in the bottom illustration, but this time the value was modulated.

In most cases, it is a good idea when varying the value of a single color in a large area to avoid values lighter than the lightest value in the subject matter. Another thing to remember is that large and overly dappled negative spaces can easily call too much attention to themselves by appearing too busy.

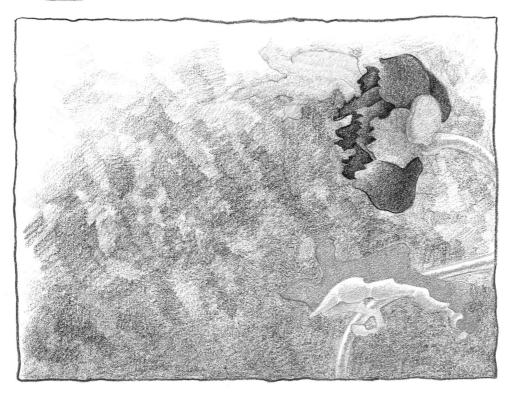

Single Layer Techniques

Working With Juxtaposed Colors

Juxtaposing colors—applying them side by side—was discussed earlier. Single pencil layers of two or more juxtaposed colors are particularly useful for handling large areas.

How each artist selects colors always depends on per-

sonal choice and the needs of a color scheme. However, choosing colors for juxtaposition that are closely related in intensity and value can help knit them together. And since a large area is being covered, juxtaposing low-intensity colors results in an additional note of complexity.

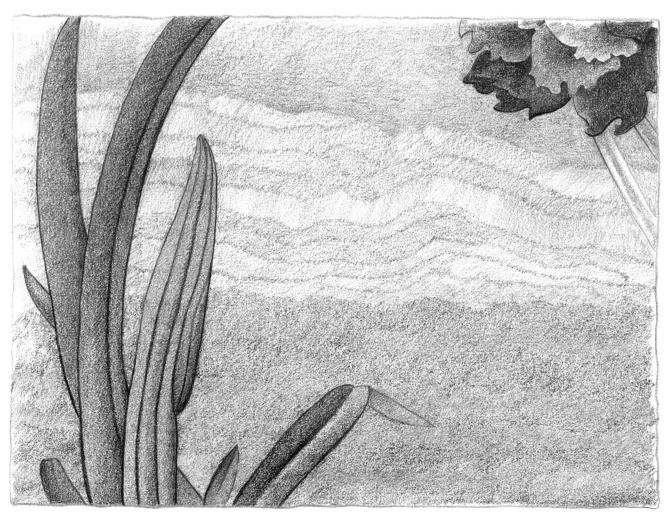

Three low-intensity pencils were used for the large area of negative space in this drawing: 937 Tuscan Red, 945 Sienna Brown, and 947 Burnt Umber. They were not layered but instead were juxtaposed with only scant overlapping.

Working With Grays

Sometimes a large area can be very effectively rendered with an achromatic color such as gray. In fact, grays can be excellent foils for bright colors and often seem to increase the intensity of adjoining tints.

But colored pencils don't mix to gray easily. For this reason, pencil manufacturers offer a variety of grays of different values and temperatures. Here are eight such grays offered by Berol Prismacolor:

1050 Warm Grey 10%

1059 Cool Grey 10%

1051 Warm Grey 20%

1060 Cool Grey 20%

1056 Warm Grey 70%

1065 Cool Grey 70%

1058 Warm Grey 90%

1067 Cool Grey 90%

Activating Gray Gray has a curious power: It may coexist placidly with other colors, or it may take on an elusive color of its own, an approximate complementary of the color nearby. This is called an activated gray. A product of simultaneous contrast, this optical effect occurs when gray is joined with a color of a similar value. Gray remains inactive when joined with a color of a contrasting value.

The above gray is inactive. The same gray below is activated: The adjoining orange color, which is close in value to the gray, causes its bluish complement to appear and disappear in the gray areas. To see this, look first at the orange color, then let your gaze wander within the gray.

Working to Edges

By its nature, drawing with a sharpened pencil—graphite or colored—appeals particularly to the artist who prefers a clear, crisp delineation of form. To this end, a great deal of time is quietly spent constructing edges where the shapes or contours of elements come together. With colored pencils, however, there are several faster ways than those traditionally employed for working to edges.

These methods are not "shortcuts" in the sense that they lessen quality; rather, they seize the opportunities offered by the colored pencil medium itself. The fact is, colored pencil edges that are made with increased speed can almost always duplicate the character of slower-made edges. And by avoiding the drastic slowdown that often accompanies the handling of edges, faster-made edges can also preserve much vital creative momentum.

Of course, some areas will continue to require acute concentration and extra time. But for those areas where the medium favors greater speed, it is simply a matter of matching up colored pencil techniques with the appropriate edge situations.

Using Graphite for Edges

Graphite pencils are frequently used to establish guidelines, which are then erased as the color work proceeds. This time-consuming erasure step is generally unnecessary, except when very light-colored passages are being developed. Think of graphite as simply a color of very low intensity, for in practice it often acts like a chameleon, blending invisibly into its surrounding environment.

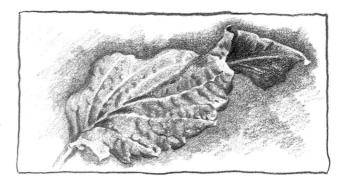

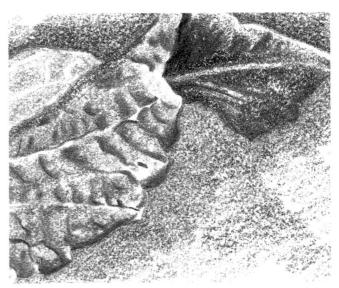

The graphite edge is virtually invisible in this drawing of a leaf (top), even though it has not been erased or even lightened. A closer view (bottom) shows the graphite is still barely visible; it has either blended with the green or been hidden by it.

A variety of edge qualities can be seen in this drawing: blurred, hard, linear, high contrast and low contrast. This is not unusual in a drawing or painting, and it affords many opportunities for using a variety of fast-working edge techniques.

Cat and Poppies Colored pencil on two-ply Strathmore bristol board, 14" × 11" (35.6cm× 27.9cm). Private collection.

Working to Edges

When working to an edge with two layers of color, try laying in the darker color first. Use this pencil to carefully describe the edge. The second layer, made with the less conspicuous lighter pencil, can then be applied fairly casually, letting this layer only approximately (rather than precisely) meet the edge. You will find that edges fashioned in this way look no different from slowly drawn edges, but you will have had to work slowly and precisely only once instead of twice.

In this small design, 932 Violet was used as the first layer. Because it is the darker of the two colors planned for the area, the violet was used to carefully delineate the edge.

The second layer, 903 True Blue, was then applied. Because it is lighter than the original violet, there was no need to slow down this time. Sometimes the blue touches the edge, sometimes it doesn't—but the imprecision does not appear to be a problem.

Letting Colors Spill Over Edges

Allow light colors to spill over into darker surrounds. Lighter colors influence dark passages only very slightly, if at all, and even when light colors do spill over, the resulting edge can look as crisp as one that took twice as long to draw. This technique can sometimes be used with colors that are close in value if they are also similar in hue.

The first rectangle (A) was shaped by quickly—and less than precisely—laying in the light color of the negative space. In the finished rectangle (B), the more carefully applied darker color easily conceals the lighter color that spilled into that area. This would have worked equally well had the order of application been reversed.

In the second rectangle (C), a darker color has been used for the negative space; it has been applied imprecisely. The completed rectangle (D) was drawn with a color similar in both hue and value to the background. Again, the edge imperfections are masked.

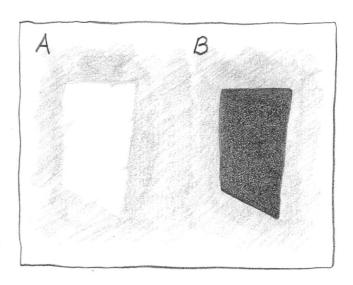

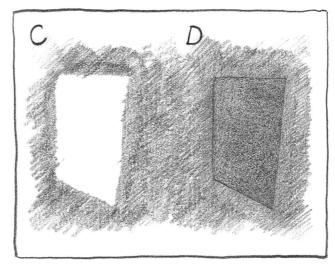

Avoiding Haloes Gains in speed may also lead to improvements in edge quality. One reason: Just giving more consideration to how shapes are joined can improve edge character. A more important reason: Trying too hard to stay within lines—a kind of coloring-book approach—often results in tiny unintentional rims of light between shapes. Such a halo effect is shown in the small design at right. The cure for edge halo is using the edge techniques discussed and adopting a more relaxed attitude about drawing across edges.

Working to Edges

Working to a Linear Edge

When a colored line is to abut or surround an area of contrasting color, it is important that the line not be accidentally toned over and the purity of its color lost. To quickly preserve a very distinct line, colored lines can be impressed.

On Soft Surfaces

There is a simple way to draw lines that remain distinct even when surrounded by tonal work; this only works on soft surfaces, however. When you draw the linear details, use extra pressure to impress the line into the surface of the paper or board. Tonal strokes applied afterward will skip across the impressed colored lines, leaving them unchanged. This technique was used in *Blue Floral* (below), which was drawn on soft four-ply Rising museum board; the linear edges are visible on the spearlike leaves as well as on some of the lower leaves.

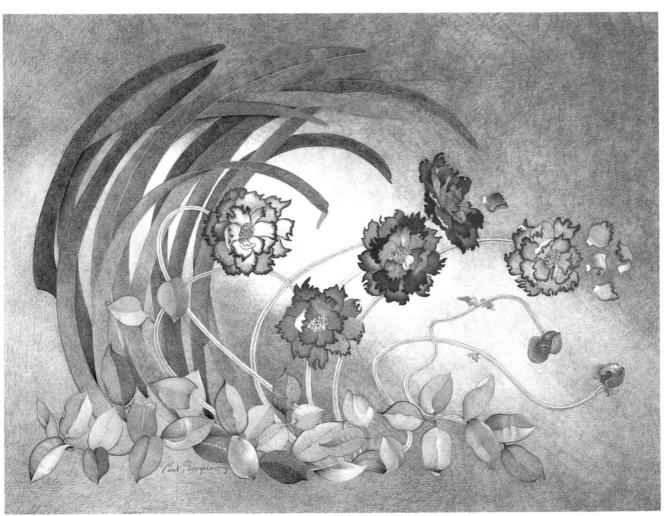

Blue Floral Colored pencil on four-ply Rising museum board, $25" \times 33"$ (63.5cm $\times 83.8$ cm).

On Harder Surfaces

There are at least two situations in which colored linear edges cannot be preserved with heavier pencil pressure alone: The colored line may be of light value, and thus must be drawn with light pressure, or the working surface may be relatively hard. In both these cases, a colored line can be impressed with a tracing paper technique.

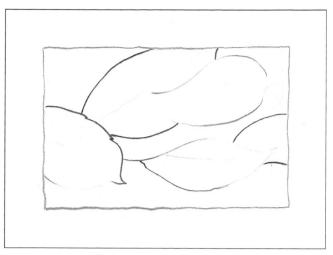

Imagine this small passage is part of a larger drawing. The tonal work will describe leaves, with some linear edges for hue contrast. Following light graphite guidelines, I drew the linear edges with various colored pencils, using medium pressure.

The area was then covered with a piece of tracing paper and, with an HB graphite pencil and firm pressure, I traced over the colored lines. The time you spend on this step will be more than regained as you proceed.

The tracing paper has been removed, and the process of applying tonal color to leaves and negative space has begun. Because my linear edges are now safely impressed below the paper's surface, the tonal work proceeds rapidly, crossing over colored lines with no danger of obscuring or losing them. This can be seen where the green has been applied over clearly visible red and yellow lines.

Injecting Color

I njecting color refers to inserting an additional new color into a lightened area. It is similar to the earlier discussed technique of spot-layering but is more appropriate to large, uncomplicated areas and is primarily used to modulate *color* rather than *form*.

Injected color, which has the effect of increasing the richness of an otherwise static passage, can be used in two ways.

1. It can be used after color has been applied to a large

area, leaving small intervals as "holes" of much lighter value. Another color is then injected into these lighter areas, creating a subtle (or not so subtle) color change.

2. It can also be employed as a remedy rather than as a preplanned strategy. In this case, a kneaded eraser is used to lighten small portions of an area where a color change or modification is wanted. Additional color is then injected into these newly made intervals of lighter value.

In the example above, a single 931 Dark Purple colored pencil was used for a passage of unmodulated color.

To inject color into a passage, a space must be made for it. This can be done as initial color application proceeds (as shown here) or afterward by lifting pigment away with a kneaded eraser. Note that interior edges are subtly feathered, with no abrupt joining of dark and light values.

A 924 Crimson Red has now been "injected" into the surrounding purple. This modulates the passage's hue and intensity and adds to its overall richness.

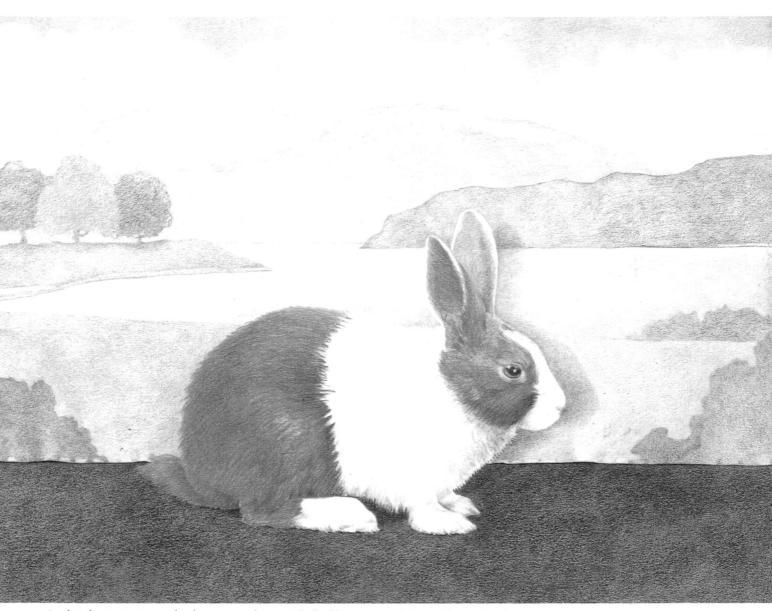

In this drawing, injected color was used to enrich the blueviolet of the floor. Two colors—933 Violet Blue and 931 Dark Purple—were used to establish the plane of the floor. Several small areas in this plane were left lighter in anticipation of injecting a third color. A 923 Scarlet Lake was then feathered into the light areas. Values were kept the same so the solidity of the floor itself would not be compromised.

Rabbit and Studio Landscape
Colored pencil on two-ply Strathmore bristol board,
16" × 22" (40.6cm × 55.9cm).
Collection of Neal and Adrienne Salomon, Portland, Oregon.

Injecting Color

M y goal will be to make simple layers of color within the large areas of this drawing appear to contain a richness usually achieved by more complex layering.

Step One Graphite guidelines were laid in on a sheet of Westwinds paper. The image size is $18^34'' \times 24^42''$, a relatively large size for a drawing, and ordinarily I would simply use Art Stix to save time. But in this case the background is very fragmented, due to the floral design, and I cannot depend on Art Stix alone. I will save time instead by using a simple two-layer approach, with a third color injected in just a few areas for more interesting hue variations.

Step Two Some color has now been developed in the background, on the tabletop, and in a few of the flowers. Specifically, here's what is happening in the background:

A 901 Indigo Blue was applied, leaving some areas much lighter in value than others. These areas can clearly be seen in the upper right side of the drawing. In the left side, I've begun applying a second layer, this time of 937 Tuscan Red. It has been applied with varying pressure over the blue, except in the open "holes." I have "injected" a 931 Dark Purple into these light areas. Because the small areas were very light, the purple asserts itself very clearly.

Injecting Color

Step Three The second layer of 937 Tuscan Red was applied to the rest of the background, and the remaining light areas were injected with 931 Dark Purple. The result is a gradual modulation of hue, value and intensity.

The rabbit was also begun, using linear strokes of various reds and oranges, and the tabletop's second color, 901 Indigo Blue, has been applied over the first layer of 941 Light Umber. Some of the color is being lifted away from this area with a kneaded eraser, in preparation for the injection of what I now believe is a needed cooler note toward the back.

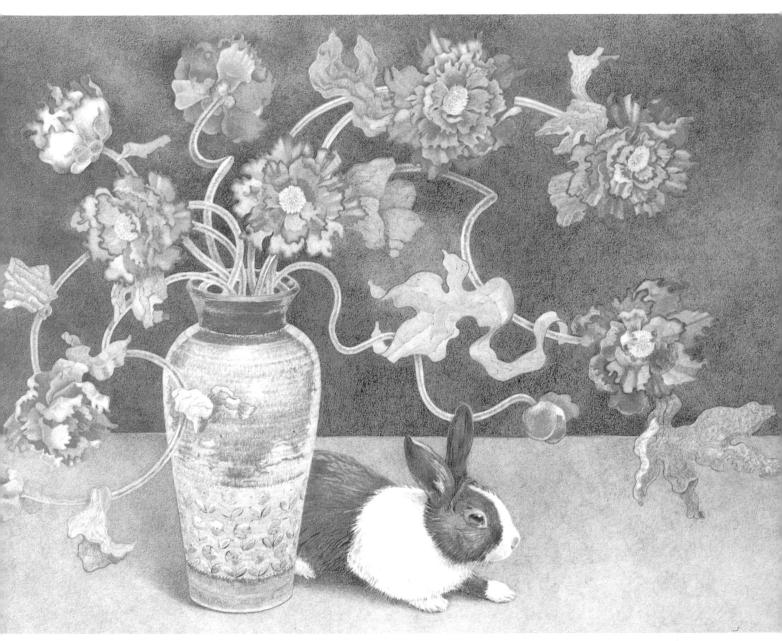

Step Four To finish this drawing, the vase and flowers were completed. The rabbit was softened with more color applied tonally over its linear stage.

When I assessed the background, the injected purple seemed about right; no adjustment was needed. How much an injected color shows will always depend on how light the "hole" for it was allowed to remain and on the color chosen for this purpose. To cool the rear area of the tabletop, constructed with 941 Light

Umber under 901 Indigo Blue, some of the Light Umber had to be removed. This was done by lifting away both colors and injecting 901 Indigo Blue. Because Indigo Blue was the original second layer, it blends in very subtly.

Rabbit and Flowers
Colored pencil on Westwinds paper, $18\frac{3}{4}" \times 24\frac{1}{2}"$ (47.6cm×66.2cm). Private collection.

An Imprimatura Technique

I mprimatura is an Italian word that refers to the staining of a surface preparatory to painting on it. For our purposes, we may think of imprimatura as a tonal application of color to all or most of a surface before a drawing is begun on it.

This preparatory layer, applied rapidly with a colored pencil or broad stick of color, can become the first layer of color for a drawing's subject and can also serve as its background, often with little or no further work.

An added dividend of imprimatura—besides a drastic reduction in background layering time—is that a single color, common to all further mixtures, usually helps unite any drawing's overall hue scheme.

Here is an imprimatura applied prior to drawing. It can be given a textural look (as shown) or not, as a matter of personal choice. This imprimatura and those for the two following drawings were made with a 903 True Blue pencil, using medium pressure.

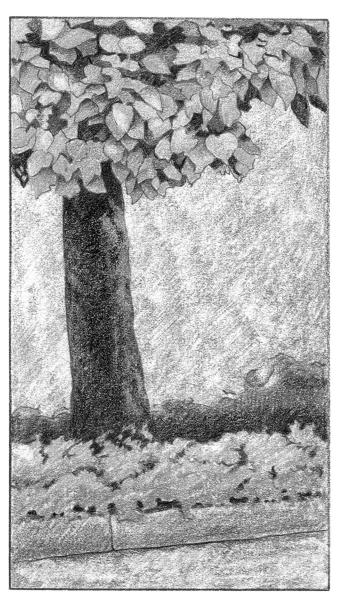

For this drawing, a hue scheme analogous to the imprimatura was chosen. The leaves and shrubs were drawn with various greens, and some of the imprimatura was allowed to show. No changes or refinements have been added to the original 903 True Blue of the background.

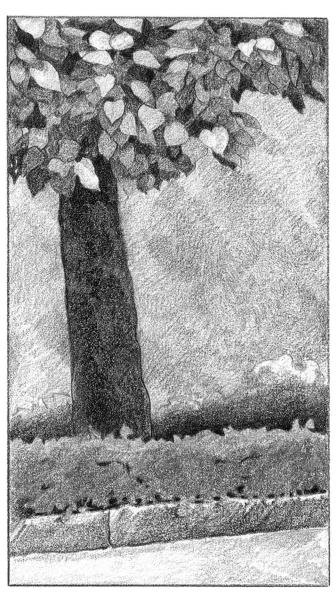

In this drawing—still with the same kind of imprimatura—a warm color scheme contrasts with the background. A kneaded eraser was used to lighten various areas of the imprimatura. Then a 932 Violet pencil was spot-layered into some of the lightened areas to enrich the background.

Imprimatura Technique

A drawing to be built on an imprimatura begins much like any other, with perhaps only a partial idea and a few thumbnail sketches. But it differs from other drawings in one very important way: It is critical that a color scheme be worked out ahead of time to ensure that the chosen imprimatura can successfully serve as a first layer for both background and subject.

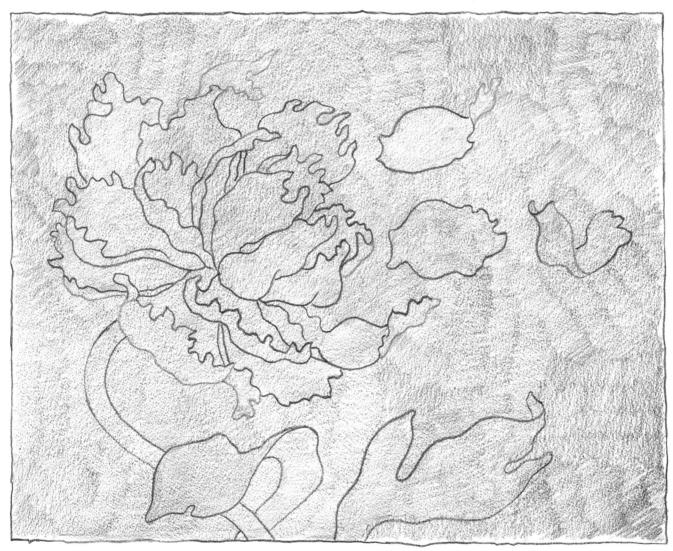

Step One An analogous color scheme of red and red-violet was planned for this small drawing. I applied a layer of 931 Dark Purple to the entire surface of a sheet of Strathmore bristol board. This imprimatura layer was done quickly and the strokes go in all directions; I made no attempt to refine gestural texture. Over this, I drew the simple outlines of my drawing's image with colored pencil.

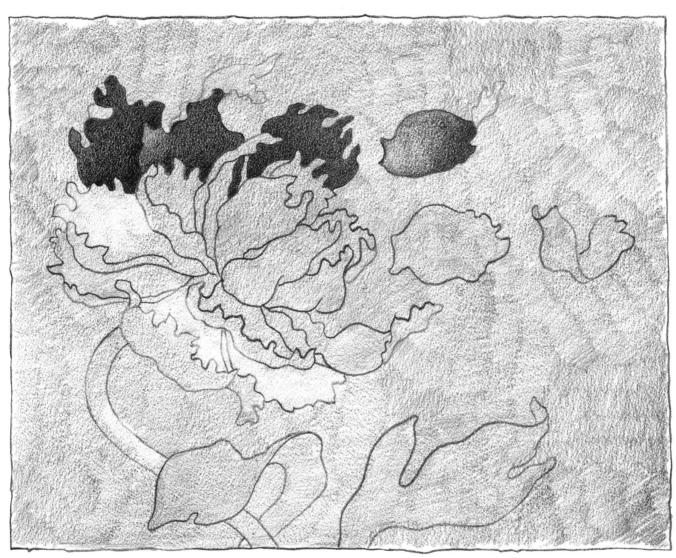

Step Two A 923 Scarlet Lake was applied to the flower petals and a 931 Dark Purple spot-layered into it for some alayeral effects. With a kneaded eraser, I also lifted away a portion of the imprimatura in the foreground petals so that when I applied the same 923 Scarlet Lake to them they would appear brighter than the petals above.

Imprimatura Technique

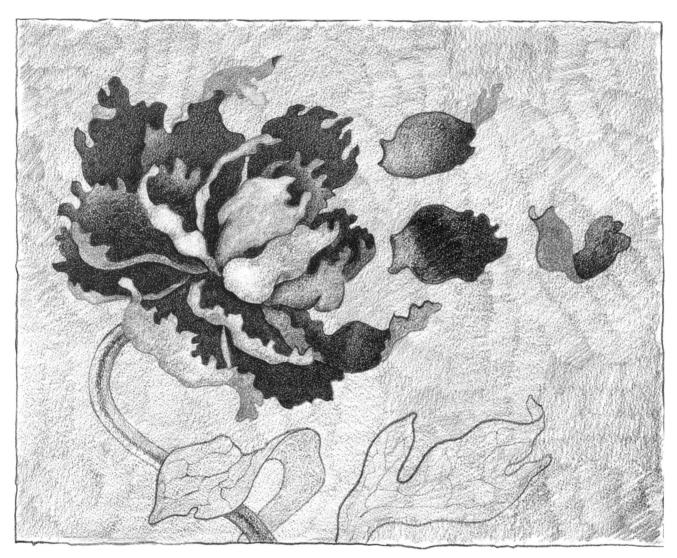

Step Three The other petals have now been brought to the same point as the first ones, using the same techniques and colors—923 Scarlet Lake for the petals and 931 Dark Purple for dark values. A 918 Orange was also applied to the petals' undersides, and a 912 Apple Green and 911 Olive Green were used linearly to establish the veins and undersides of the leaves. All these colors mix well with the original imprimatura layer, causing their separate intensities to be somewhat muted.

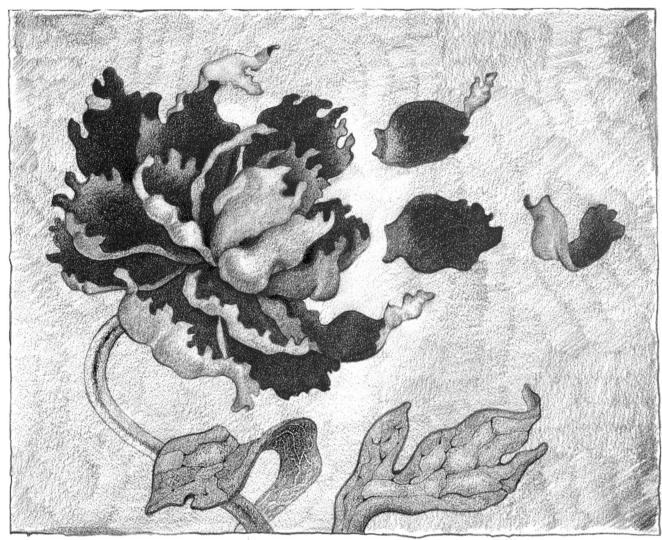

Step Four After assessing the values in this drawing, I decided to lift away and lighten some of the imprimatura in the center. Using the 901 Indigo Blue, I also darkened some of the flower's petals. This helped stretch the value range.

A sharp 922 Poppy Red pencil was used to further reduce the white grain of the paper, making the flower colors appear more saturated. Some of the petal forms were developed further, and the leaves were modeled with a single tonal layer of several related juxtaposed colors.

The only modifications of the original imprimatura in this drawing are a lightening in the foreground petals, a small value change at the center, and a final slight darkening at the drawing's right corners for balance.

Peony Colored pencil on paper, $6\frac{1}{8}" \times 5^{5}\frac{8}{8}"$ (15.6cm× 13.2cm). Collection of Mr. and Mrs. Thomas Caddy, Toutdale, Oregon.

Gain Complexity With Texture

S tacking several layers of pencil color over one another can create the richness and complexity of appearance for which this medium is well-known. But deep layering is time-intensive, and is a technique often better saved for special areas of interest. For other areas, a rich complexity can often be expressed without a lengthy expenditure of time and effort, but rather with use of an ambient, or allover, texture.

There are many known ways of creating textures, and probably many more yet to be invented. A very basic strategy is to alter or "distress" parts of a surface before applying tonal color over it. This can be done very simply

and quickly—after a drawing's major elements are indicated—by using a white or light-colored pencil to make a series of marks or patterns throughout a large area.

Color work is then begun as usual, ignoring the barely visible marks. But each time a pencil crosses a waxy mark, its color and texture will look slightly altered. The net result of this will be single layers of color that look as if constructed of multiple layers. With this basic strategy, plus personal experimentation, you may soon discover a number of textural techniques of this kind which allow you to work faster and more spontaneously.

In A (above), a 938 White was used to distress the surface before a 992 Light Aqua was applied. In B, the distressing pencil was a 914 Cream. Pencil pressure for both the white and the cream was medium at the top and firm at the bottom. With this technique, paper hardness will affect the result. Both these examples were drawn on medium-soft Westwinds paper.

At an early stage in this drawing, the negative space was distressed with a white pencil. Two layers of color were then applied, revealing a texture that appears lost and found depending on how it is viewed.

Night Bouquet II
Colored pencil on three-ply Strathmore bristol board, $18^{1}/2^{n} \times 13^{n}$ $(47.0cm \times 13.0cm)$.

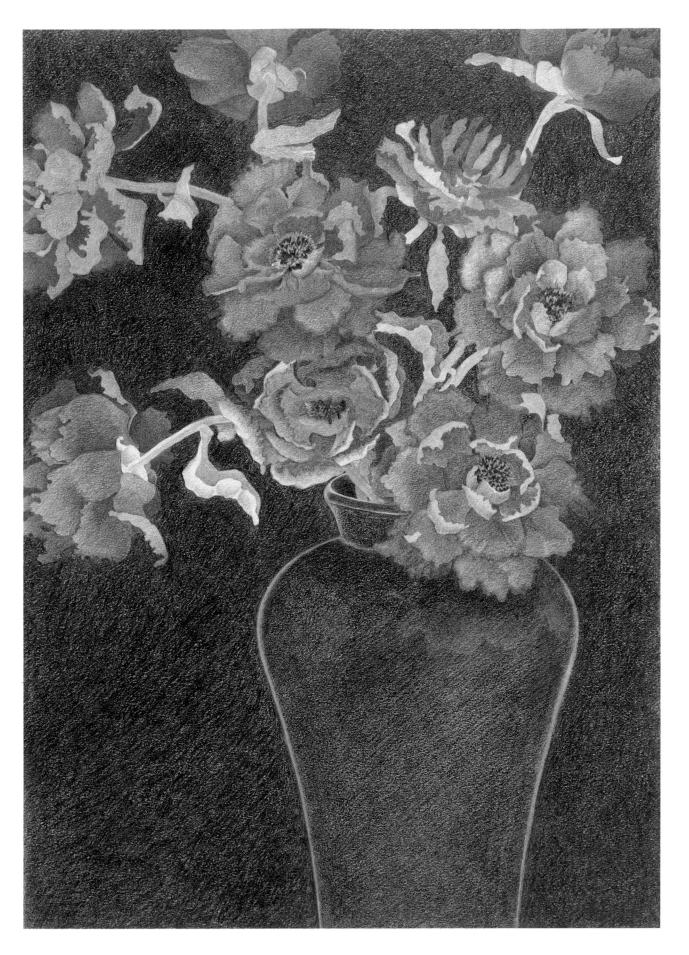

Techniques to Handle Backgrounds and Other Large Areas

A Surface-Distressing Technique

This illustration is designed to suggest a detail within a larger drawing. The background will consist of a single layer of color, but the paper itself will be altered to make the color appear varied.

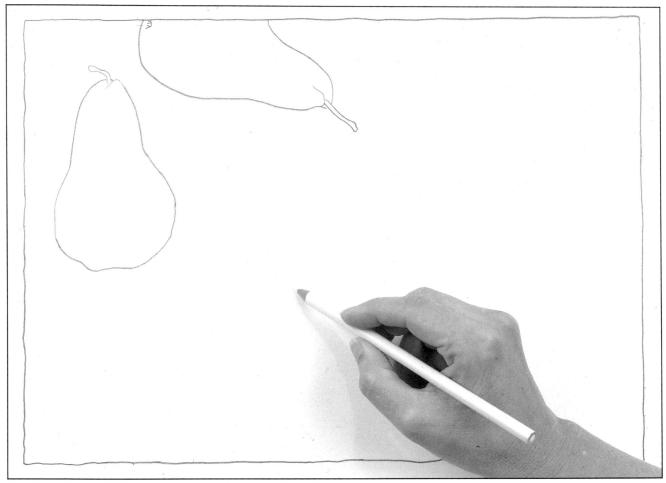

Step One After establishing graphite guidelines, I used a 914 Cream pencil to quickly apply a broken stripe pattern in the negative space only. This mark is somewhat structured, and I didn't want it to become too assertive, so I applied the cream pencil lightly, just enough to make slick dashes of wax.

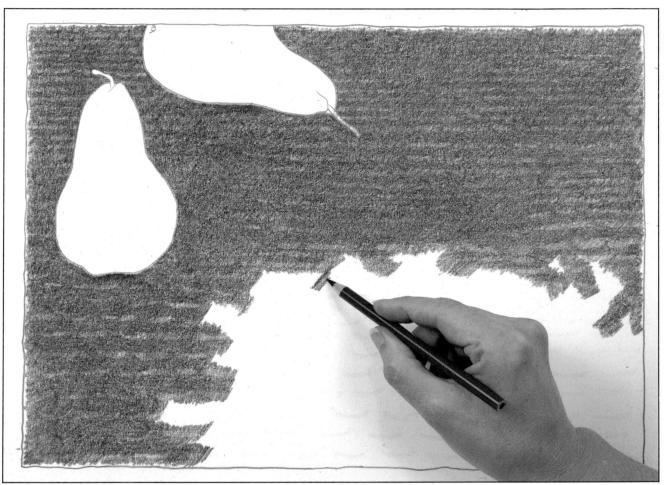

Stop Two With a 931 Dark Purple pencil I applied a fairly dense single layer of color, disregarding the waxy marks. Regardless of how lightly or heavily this layer is applied, its color will be affected each time it crosses over the waxy mark of the cream pencil.

In the close-up view, the cream-colored marks can be clearly seen through the overall purple layer. Had the marks been made with a white pencil, the purple would have taken on a cooler cast.

Using a White Background

L deal of time. But in color drawing, the key to making a white background work is to actively plan for it, rather than let it occur by default. When a white background is to be used, it is critical that the color scheme and composition be designed for it. To sidestep such planning is to practically guarantee poor results.

Difficulties With White Backgrounds

There are at least two major reasons why white backgrounds can be disappointing:

1. Almost nothing in nature is flat white. Therefore, an expanse of white in an otherwise hue-laden drawing looks false and contrasts too much with the colors and

modeled forms. An unyielding white opacity is often simply too raw—even snow and the lightest of highlights contain many delicate and modulated tints.

2. White dominates in a design. Because white is expansive and thus appears to come forward, a large white background can confuse and diminish a drawing's subject. Areas of brilliant white can also darken nearby colors and weaken their luminosity.

How to Make White Backgrounds Work

To successfully use white backgrounds with color drawings, it is necessary to focus carefully on your composition and color scheme.

It is unusual for an artist to remove a subject from at

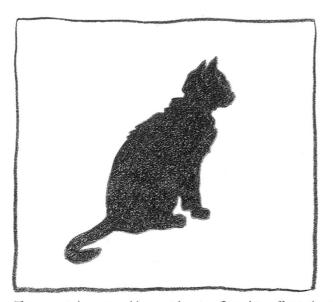

There are inherent problems with using flat white effectively as a background. These occur because white is one of the two extremes in the value scale and is profoundly expansive. This can be clearly seen in the two small drawings above.

The black cat at left contracts and looks like a small cutout within the white field. The white also seems to come forward around the cat. In the example at right, the whiteness of the cat brings it forward, and it appears larger than the black cat although it is really slightly smaller.

least a suggestion of its usual context. When this is done—as it is so handsomely by botanical and scientific illustrators—we instantly know that we are being shown a specimen that has been deliberately removed from its environment and presented for greater clarity against a blank or nonessential background.

Two factors will help you successfully integrate a colored subject and a white backdrop:

- 1. Minimize white negative space. The size of a white background can have a profound effect on its power.
- 2. Minimize contrasts between colored positive and white negative space. It is often possible to arrange fragments or shapes of white within a subject. Soft edges or sketchy outside contour lines can also help ease transitions between subject and background.

Color schemes are also important when you are using a white background. White is a powerful element, and it is worth the time it takes to plan a color scheme for it. If you decide, for instance, to work with a splitcomplementary color scheme and no background, you must think of white as an active member of the color team.

It is also worth noting that some art theorists believe there to be an affinity between white and the upper end of the hue spectrum, blue-green through violet. This theory, if correct, implies that a bluish color may harmonize well with white, while a color near the other end of the spectrum, such as brown, may create tension. The important thing here, of course, is not which effect is better (either can be) but being able to plan it.

Still another consideration is that paper itself has temperature. White drawing papers can range from bluish (with names like polar or arctic white) to yellowish (such as warm or antique white). Some artists prefer a cool white because with time and exposure to light such a paper will probably grow warmer. A paper that has a warm cast to begin with, on the other hand, may eventually become too yellow.

Our perception of color is dynamic; it depends a great deal on what adjoins or surrounds it. Large areas of white often have a predictable influence on nearby colors.

The two drawings above illustrate how white tends to darken color and reduce luminosity. Both cats were drawn with 913 Spring Green at full pressure, and they are physically identical. But in the drawing at left, the color of the cat appears darker due to the brilliance of the white background. And the luminosity of the green—so visible in the drawing at right—has been extinguished.

Using a White Background

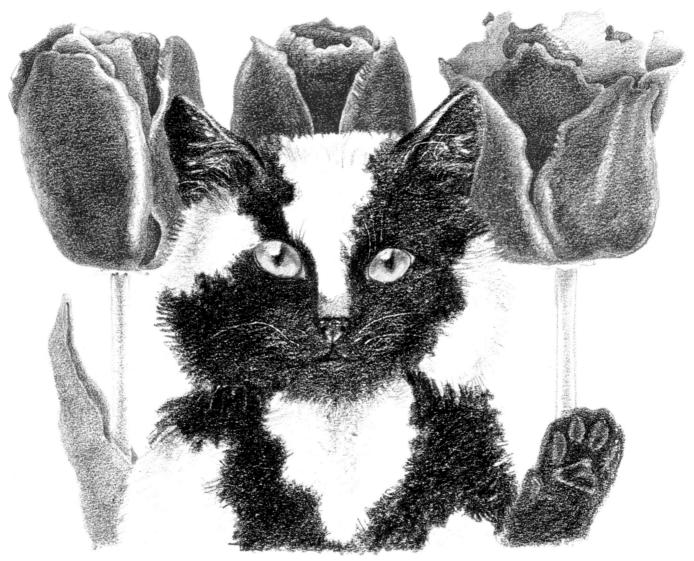

This drawing relies on two strategies for dealing with the white background. One is an arrangement of elements—a composition—designed to minimize the amount of white negative space. The other is based on the fact that a white background often works well with a color drawing that has strong black and white elements. A possible explanation for this is that we are accustomed to seeing drawings in black and white media (graphite, ink, charcoal) with little or no background.

Technically, the black parts of the cat are layered blue and brown, the red-orange blooms are a major element, and green foliage is also included. But the dominant feeling of the color scheme is black and white—which we easily accept with only white paper as negative space.

Cat of Prosperity
Colored pencil on two-ply Strathmore bristol board, $5\frac{1}{2}$ " \times 7" (14.0cm \times 17.8cm). Private collection.

This drawing—one of a series of florals on white back-grounds—relies heavily on a compositional strategy to help soften the transitions between positive and negative space. The strategy was to arrange white shapes within a subject. While the white is not actually a part of the floral forms, the meandering stems corral and embrace enough negative space to make it seem part of the subject's color.

The color scheme was also planned with a white background in mind. Because the cool end of the spectrum appears to be compatible with white, the color scheme has been kept cool; even the scarlet flowers have been cooled with some lavender petals.

White Floral #3 Colored pencil on Rising museum board, $31" \times 38"$ (78.7cm \times 96.5cm).

Using a Vignette

The vignette is characterized by a gradual reduction or fading away of some of a drawing's peripheral elements; it is essentially a means of transition between subject and background. This device can save time because it lessens work on the background. Artists use it to emphasize a center of interest, and it is a familiar device in portraiture, where the background must not be allowed to distract from the face. It can also impart an air of informality and spontaneity.

While there are many techniques for producing an effective vignette, one tenet seems constant: A truly successful vignette cannot be merely imposed on or done to a drawing. It must instead flow out of or seem to emanate from the subject itself. A good vignette has a look of having suddenly—almost accidentally—happened. Actually, the traditional drawing strokes for producing it are more likely to have been carefully developed and practiced, and they are a major factor in the overall mood of the drawing.

These small color drawings show a subject with three kinds of background, two of them vignettes. Both the foreground and the background of the first drawing are fully rendered. It contains the kind of simple and straightforward subject, however, that seems likely to lend itself to a vignette technique.

This time the subject was composed as in the first version, but ink was used to establish much of the drawing in a linear fashion. Color was then applied tonally within the lion—the drawing's center of interest—and some of it spills out into the other elements. It helps, when incorporating a great deal of white in background and foreground, to also allow some white to remain in the subject for a smoother integration of elements.

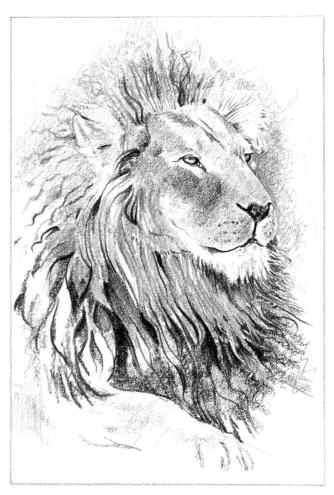

For this second vignette, the lion's head was composed somewhat larger within the total frame of reference. The background and foreground were de-emphasized further and retain only a suggestion of their original colors. Again, white was allowed to remain in some of the subject—notably the lion's mane—to soften the contrast between positive and negative space. This type of vignette is frequently used in portraiture.

Colored Surfaces

Olored pencil work on a colored surface often has a quiet and richly luminous look. Working on a colored surface can also increase drawing speed. The three main factors that contribute to this are: a colored surface can itself serve as a drawing's negative space; layering time is sharply reduced when a colored surface becomes the first layer of color; and the value of a colored surface functions as part of a drawing's total value range.

The most familiar colored surface for drawing is colored paper. One widely available brand is Canson Mi Teintes, which offers 35 colors of varying values and intensities and is considered very light resistant.

A second type of colored drawing surface is colored mat board. These boards were originally designed for matting artwork. Many of them now meet conservation standards, and their drawing surfaces have excellent resilience for layering, as well as for a variety of more exotic techniques.

Hand-colored boards are yet another type of colored surface. These are usually the product of personal experimentation. One method for preparing a hand-colored surface is brushing tube acrylic thinned with water onto a high-quality illustration board. Plain water is then brushed onto its back, and the painted board is clipped against another flat, sturdy board to dry. An advantage of hand-colored boards is that their color can be much less flat in appearance than that of most ready-made supports.

Selecting Colored Papers

Colored drawing papers are too often selected on the basis of hue alone, even though intensity and value can

actually be far more important.

Paper colors that are too intense can overwhelm any color pencil work done on them. A paper's value can also present serious problems. Fortunately, the effect a colored paper's value is likely to have on a colored pencil drawing is fairly predictable. Here are a few guidelines:

Light value range

Colored papers in this group tend to darken pencil colors. A drawing with many light passages would probably suffer. Low-key work is better suited to these values.

Middle value range

There is a long tradition of using colored or neutral papers in this group. A full value range can quickly be expressed with one light and one dark pencil.

Dark value range

It is with these values of colored papers that colored pencils can appear their most luminous.

Black paper

This represents an extreme in the value range, and even though black papers are not truly black, working on them can mean contending with a great deal of unmodulated dark value. Also, while it would seem that the paper's own dark value could be a drawing's darkest, this is not always so. Because even the darkest papers are not actually all that dark, a 901 Indigo Blue or a 935 Black is still needed for a truly dark note.

Colored Papers There are many kinds and degrees of surface texture among the various brands of colored papers. Some papers also have less texture on one side than on the other. Colored pencils generally perform best on colored papers with very little texture.

These fourteen samples of colored paper are from the Canson Mi Teintes line and are particularly useful with colored pencils. It is interesting to note that although the colors shown have been divided into their relative value groups, all are actually within or very close to a middle range on a true value chart.

Selecting a Palette

P encil colors can appear dramatically unlike their customary selves on various colored papers. For this reason, each colored paper may require a different colored pencil palette.

A good way to cope with this complication is to simply

experiment with pencil colors on actual swatches of the colored paper to be used. Shown here, for example, are a group of identical pencils applied to a white and three colored papers.

White Paper This first grid shows how we are accustomed to seeing our pencil colors. There are three approximate groupings within it: one of six dark colored pencils, a second of six cool pencils, and another of eight warm pencils.

343 Pearl (Light Value Range) Some of the pencil colors here begin to appear more vivid than those on the white paper, but not as much so as on the two darker papers. The pink grid itself appears darker here than on the darker papers but lighter than on the white. It is now necessary to add white (or a very light color) to get a light color.

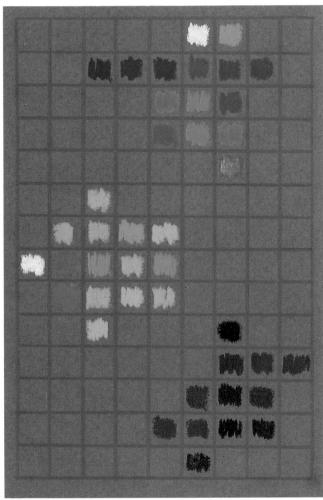

502 Bisque (Middle Value Range) With this paper, another complication is suddenly present. The paper itself has a very definite hue—ochre—which mixes with the pencil colors. The warm red-orange pencils are analogous with the paper; their colors are intensified. The cool blue-green group, however, is nearly complementary; pencil colors in this group seem to vibrate. The pink grid—because it is so similar in hue and value to the paper—takes on some of that mysterious quality a closely related color often attains as it becomes nearly invisible.

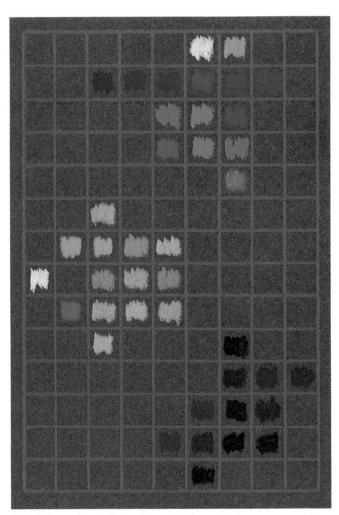

501 Tobacco (Dark Value Range) It is on darker papers such as this that pencil colors become most luminous. Compare this pink grid with the three other pink grids. Also present is a kind of clarity that occurs when pencil colors are vivid and contrast well with a surface. Although such contrast can be very high with the white paper, a white paper's own brilliance often reduces the vividness of the pencils. This does not happen when the same pencils are used on a dark surface.

Enlisting Other Media

A great attraction of the colored pencil medium for many artists is its simplicity and lack of paraphernalia. But there are also ways of saving time by adding a bit of equipment and technique from other media.

Aqueous colors, for example, can be used to quickly lay in backgrounds or large areas. This can be done with a brush and liquid acrylic or watercolor. It can also be done with an airbrush, but the expense of equipment and specialized training puts this method outside the scope of this discussion.

There are two basic problems when aqueous media

are used with colored pencils. The first—which is obvious and fairly easily managed—is that highlight passages must be reserved. Once an area is covered, there is no easy way to regain paper highlights.

The second and much trickier problem is that the granular appearance of colored pencil is dramatically different from that of painted color. Without adequate transition or blending, this can present a serious gap in a drawing's unity and credibility. In the next few pages, we will examine this major problem and some of our options for dealing with it.

The Problem Two media have been used here—with very different looks. The red area is liquid acrylic color, applied with a red sable brush. Colored pencil was used for the angular blue, green, and pink shapes. The acrylic portion looks thoroughly saturated, with no white paper flecks. The colored pencil areas do not. If two such distinctly different looking areas are to work together successfully in a single drawing, they must be blended better.

Option One In both these examples, the liquid acrylic and colored pencil were applied as before, but then a layer of colored pencil was applied over the red acrylic. In the top drawing, the pencil color is similar to the color of the acrylic. In the lower example, a completely different pencil color was loosely applied. In both cases the uncompromising quality of the acrylic has been softened, and a granular quality similar to that of colored pencil has been added. This helps unify the two mediums. (Notice that while the grain of colored pencil is usually white, colored pencils over acrylic produce a colored grain.)

Enlisting Other Media

Option Two This time, liquid acrylic color was used first to establish the entire drawing, then colored pencil was applied over it to refine the image. Overall unity with this method is very good. The principles for selecting pencil colors to layer over painted colors are similar to those used with colored papers.

Option Three In this example, the red liquid acrylic was not covered with colored pencil. Instead, the angular colored pencil shapes were applied with very heavy pencil pressure, flattening the paper so that no granular white flecks show. The elements look well integrated and their colors are nicely intense. A drawback of this method is that applying constant heavy pencil pressure is arduous work and invites wax buildup.

Option Four A combination of the other options was used for this more developed illustration. Red, light blue, and pink liquid acrylic colors were first used to establish the background and the play money. That was the total extent of the aqueous medium. Colored pencils were then used to render the remaining elements. Some of the pencil was applied with heavy pressure to relate it to the liquid color; some was used lightly for more granularity. As a final step, colored pencil was used tonally over the red acrylic and linearly over the blue and pink to render details of the money. This is a fast technique, and the dual nature of the separate media is now effectively masked.

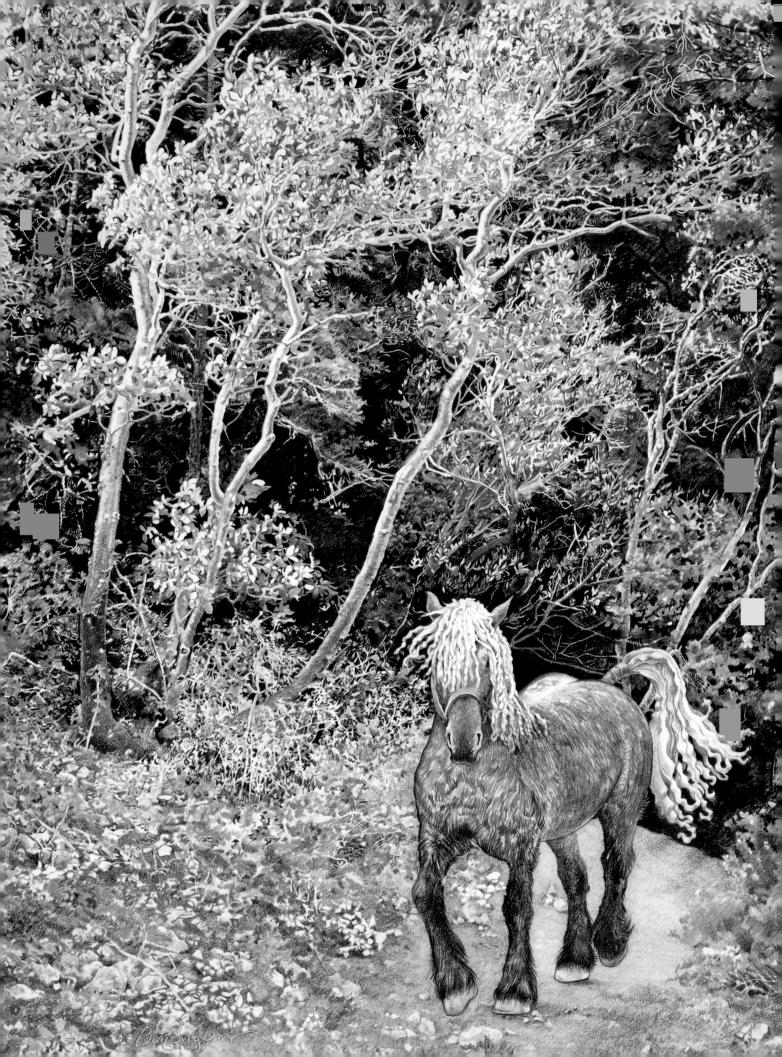

Refine Your Working Methods

The purpose of Part Three is to help you find opportunities for gaining speed when desired. After reviewing some good practices used in drawing, and also in and around the studio, we will discuss a simple but practical means for trouble-shooting your own working methods.

Draft Horse and Madrones Colored pencil on two-ply Rising museum board, 25¾" × 18½" (65.4cm× 46.9cm) Public collection.

B esides the major time-saving techniques outlined in the previous chapters, you can often find smaller ways to work and draw more efficiently with colored pencils. A few of the tips that follow offer immediate time savings. Other suggestions do not but are directed instead at avoiding the later delays of correcting a mistake or stopping in frustration. Some of these strategies may also serve as a beginning toward finding ways you can smooth out your own personal working methods.

Signing in a Dark Surround

Colored pencil drawings are usually signed within the picture itself, rather than in the margin. Because it can be difficult to do this in a dark area, signatures are sometimes forced into awkward places. One less-than-satisfactory solution to signing in an appropriate but dark area is lightening the area with a kneaded eraser—which can ruin the area's continuity. A better way is to use an impressed line technique for the signature.

Impressing a Signature A signature can be easily impressed into the appropriate area before the dark color is added. Cover the drawing with tracing paper and sign your name, using a graphite pencil and pressing down firmly. Remove the tracing paper and complete the dark passage. The signature will remain white and be clearly visible against the dark background.

In this example, the signature is white. For a colored line, a light layer of color could have been applied to the signature area before beginning the impressing step.

Working to an Edge Many artists use a ruler as a barrier for stopping multiple pencil strokes along a straight edge, but a fingernail can also serve this purpose. With a bit of practice, you can learn to easily and rapidly move your finger in unison with the pencil along a curving edge.

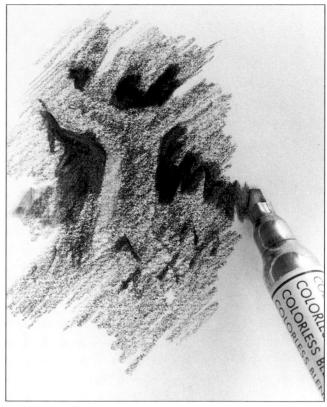

Quick Darks A colorless blender (no. 311 Design Marker) can instantly darken small areas of colored pencil without creating wax buildup. This marker which has no color of its own, contains a solvent that liquefies the colored pencil binder, making areas of pencil work flow together and darken. It dries to a matte finish, however, and a few pencil strokes are needed afterward to restore the sheen. (Remember to use any solvent only in a well-ventilated area and for no more than a few minutes at a time.)

Erasing an Impressed Line Sometimes you may want to remove impressed lines that seem overdone or in the wrong places or that were impressed accidentally. Despite the face that an impressed line tends to produce a very pronounced mark, its effect can be "erased" or greatly muted.

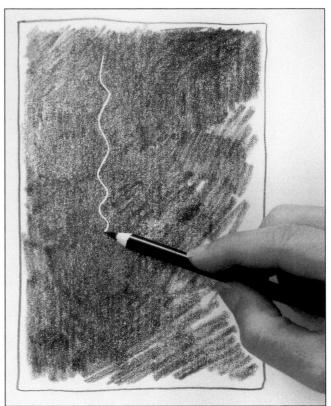

In this case the impressed line has been approximately half removed, beginning from the bottom. The "erasing" was done by sharpening the same colored pencil used for the surrounding area and running it lightly along inside the groove. The telltale reminder of a filled-in line is not the groove itself but the tiny ridges of piled-up color on each side of it. These can be concealed by slightly darkening the areas alongside the line to match the ridges.

Smoothing Dark Areas Good tonal coverage is often achieved by applying a color layer with strokes that go in many directions (see diagram above). When you use firm pressure and dark colors, the result may be an overworked look due to too many multidirectional tracks and trails. These conflicting stroke marks can be smoothed away by stroking the area lightly in one direction only with the last pencil used (see photo and sketch at right). This stroking is not intended to physically smooth the surface, nor to add color, but merely to organize the short nap of the surface for an even sheen.

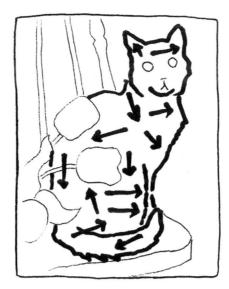

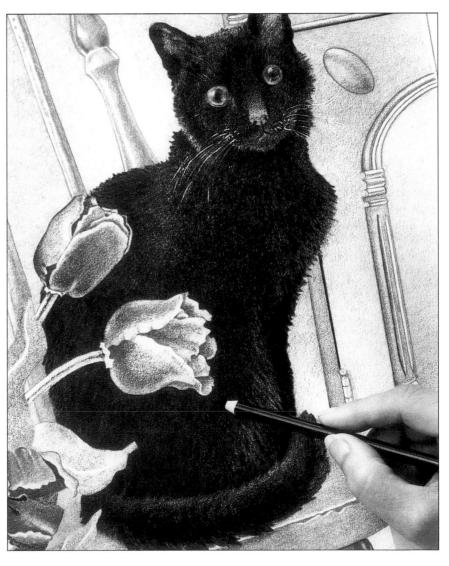

Working on Backgrounds It is sometimes a good idea, when drawing a large negative space, to work with five or six sharp pencils of the same color. This eliminates the need to resharpen a single pencil every few moments—a task that can make drawing feel too slow. It can also help keep your concentration steady when drawing a particularly tough or complicated passage.

Intensifying Color Spraying a fixative incorrectly can accidentally and drastically intensify a drawing's colors. But this potential problem can also be put to a deliberate use. In this drawing, everything has been masked off except the flowers. Carefully spraying these with a fixative for a somewhat longer than normal time—about five seconds total—greatly intensifies their colors.

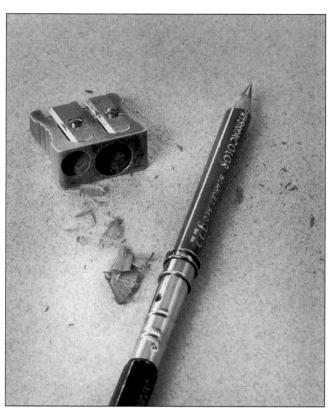

Sharpening Short Pencils Pencil extenders can add a lot of mileage to pencils. But because a short stub of pencil tends to rotate in the ferrule of the extender, sharpening it almost always means first removing it. There is a simple way of correcting this time-wasting annoyance.

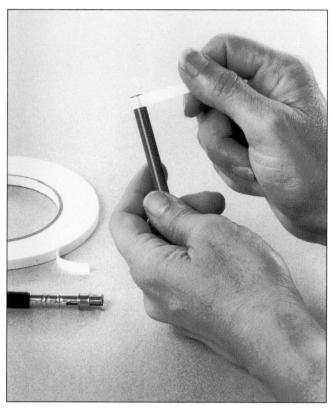

Add masking tape shims to the ends of short pencils before inserting them into extenders. A single layer of 1/4" tape usually makes a tight enough fit to keep the pencil from turning inside the extender's ferrule while sharpening. A very short but taped pencil stub can also be pulled partly out of the ferrule for a slightly longer sharpening life.

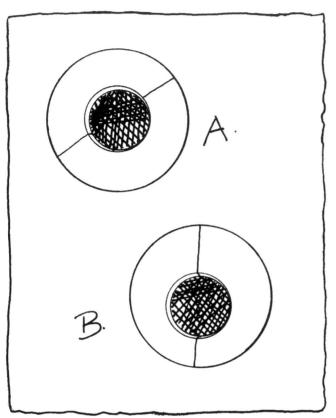

Broken Leads Pencil leads that break frequently can be very frustrating. A first step toward avoiding this nuisance is making sure that all the pencils you buy have well-centered leads (A). Avoid pencils with off-center leads (B) and those with shafts of half-dark/half-light wood, which tend to splinter and hang up in a sharpener.

Another way of avoiding broken pencil leads is changing the blades of hand-held sharpeners more often. It shouldn't take more than a few easy twists to maintain a sharp point. And try using the larger of the sharpener's two openings. This removes less wood—and snagged wood is often the real cause of a broken lead.

Sharpening on Location When you are working at locations away from your studio taboret, or standing while working on large-format drawings, try clamping a pencil shavings holder nearby. A large spring-loaded hardware clamp makes this easy to do.

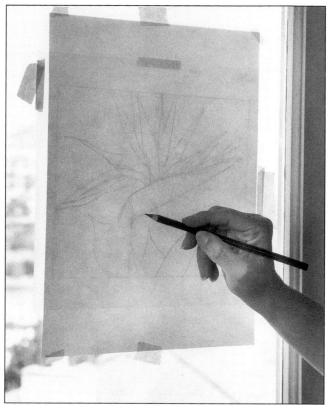

Transferring During daylight hours, a window can often substitute for a too-small or unavailable light box. Simply tape up the preliminary tracing or drawing to be transferred, then tape a clean sheet of drawing paper over it.

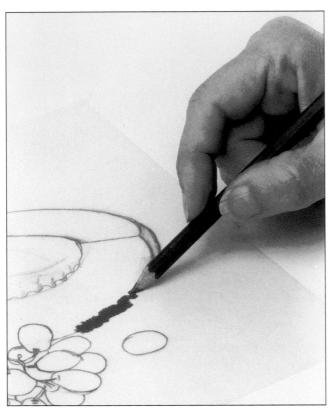

For transferring a preliminary drawing on tracing paper to a relatively thick board or to a colored paper, neither a light nor a window will work. Instead, apply a dense coat of graphite on the reverse side of the preliminary drawing, covering only the guidelines. (an old Koh-I-Noor "Blackie" pencil, if you have one, is great for this. A more readily available alternative, the Derwent Graphic 9B, also provides a suitably dense stroke.) Position the tracing paper right side up on a clean drawing surface and lightly retrace the image. Lightness of retracing is important, so no impression except a faint line will be transferred to the clean sheet.

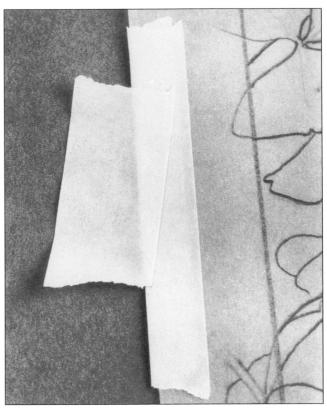

Tape on Tape Because the tracing paper so heavily used and reused in the planning and transfer stages of drawing is fragile, it often gets torn as masking tape is used and removed. A good habit when starting with such a paper is to affix two or three short lengths of doubled-over masking tape along its edges. These provide sturdy, nontearable fastening places for new tape as needed.

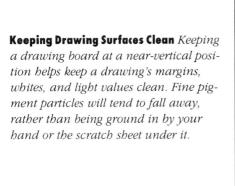

It helps also to keep a small utility brush (in this case a paint brush) nearby and to use it routinely for lightly brushing away pigment particles.

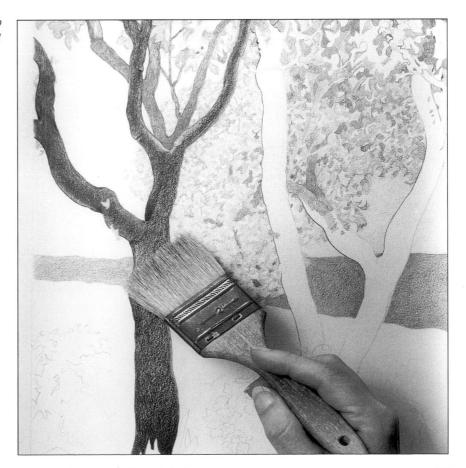

Refine Your Working Methods

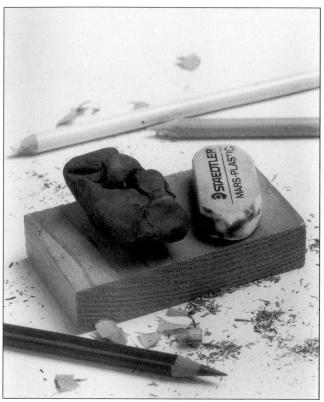

Erasers, especially kneaded erasers, can easily pick up particles of pigment from a taboret—and deposit them in a ruinous streak on a drawing's white passage or margin. This can be avoided by using a small block of wood (or a small box) as a raised surface for erasers, up out of any pigment dust.

Spraying Fixative It can be a dismaying surprise to spray a finished drawing with fixative—and see blotches of unwanted color appear in a margin. Because seemingly invisible pigment dust tends to darken and intensify with fixative, it is essential that even a visually clean finished margin be eraser-cleaned before spraying. Readying an eraser for this task can be quickly done with a few passes across the bare wood of a drawing board.

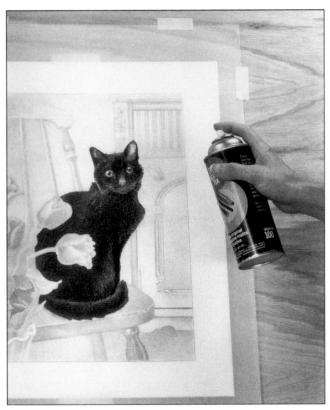

Despite any label directions to the contrary, it is always best to position colored pencil drawings vertically when spraying them, to avoid dripping solvent down onto them. It is also best (again contrary to label instructions) to spray with a few very light coats, rather than saturating a drawing (and probably drastically changing its colors). And for colored pencil work generally, only the dark or heavy pressure areas need spraying. The rest of a drawing (such as that shown with the cat) can be masked off with tracing paper.

Spraying With Good Ventilation It is very important that spraying of fixatives be done with proper ventilation. One way of achieving this is to position a drawing to be sprayed against the screen of an open window. If the drawing stands easily, or is sucked against the screen, excess spray will be carried outdoors. Should the drawing resist staying put, or push away from the screen, the airflow is wrong for spraying here. If no window works well, spray outdoors or quickly leave the room for a while after spraying. The vapor of any spray fixative can be harmful, and its potential danger must not be underrated.

Discovering Hidden Time Traps

There is another way of speeding our work, one we haven't yet discussed. It involves hidden time traps—those work habits that seem to be furthering a drawing's progress but are actually slowing it down. These stalling habits, which we all occasionally fall prey to, can add extra hours or even days to our work on a drawing.

Hidden time traps are not to be confused with the rituals artists often find necessary before setting out on any new creative journey. Tidying up a work area, sharpening every pencil in sight, pacing about—these types of "make-ready" action are merely warming up to the task at hand. Our hidden time traps involve subtle things we do in the process of drawing, not beforehand, and often look more like honest work than deliberate delay. Some examples are excessive layering, over-refining of negative space, or gravitating always to a drawing's "safe" areas to work. We can best combat such habits by discovering the uncertainties that cause them.

Confronting Uncertainties

There are many negative feelings about the word *confrontation*. It sounds aggressive and unpleasant, and maybe suggestive of trouble. But for our purposes, it can be a wonderful word. For what *confronting* really means, after all, is merely standing face to face with a situation. And that is exactly what we must do. We must very squarely face, early on, whatever we are most unsure of.

A frank realization that we are using stalling tactics can sometimes trigger the realization of what it is we are avoiding. We may, for instance, feel slightly reluctant to render a complicated form, to handle a chancy background, or to change a color we are beginning to suspect is wrong. We may even experience a dawning fear that the paper itself is not right for the piece now half-finished on it and ought to be changed. But whatever the problem, to resolve it we must confront and describe it. We must put our real reason for slowing down into specific words.

Finding a Description

It is said that artists must be good observers. The usual interpretation of this is that we must be able to see all the large and small things about a form or a scene. But this may not be the whole story. It may be equally important that we also be sharp observers of all that is happening to a drawing as work on it progresses. Acquiring this kind of objective observation is sometimes difficult, but it can be learned.

We take a giant step in this direction when we realize that if our work unaccountably slows down, it is probably because we are dodging one component by working too much at others. To pinpoint what is being avoided—sometimes an elusive task—try seeing a whole drawing as its barest components—the issues we all must face with each piece we start. These are:

- 1. Basic idea
- 2. Composition
- 3. Draftsmanship
- 4. Color
- 5. Textural character
- 6. Mood
- 7. Unity

Ask yourself, as you sift through these essential components, if each is working effectively. Describe clearly and verbally to yourself what each component is (or is not) supposed to do. Include this seven-part list in your silent dialogue, and be prepared to confront any problem areas in it immediately.

A final irony about the whole subject of hidden time traps is that the problem we try to avoid often relates to the very reason we started the work in the first place. It is what excited and motivated us. All that we are really confronting, therefore, are the vital and positive links to the things that first engaged us.

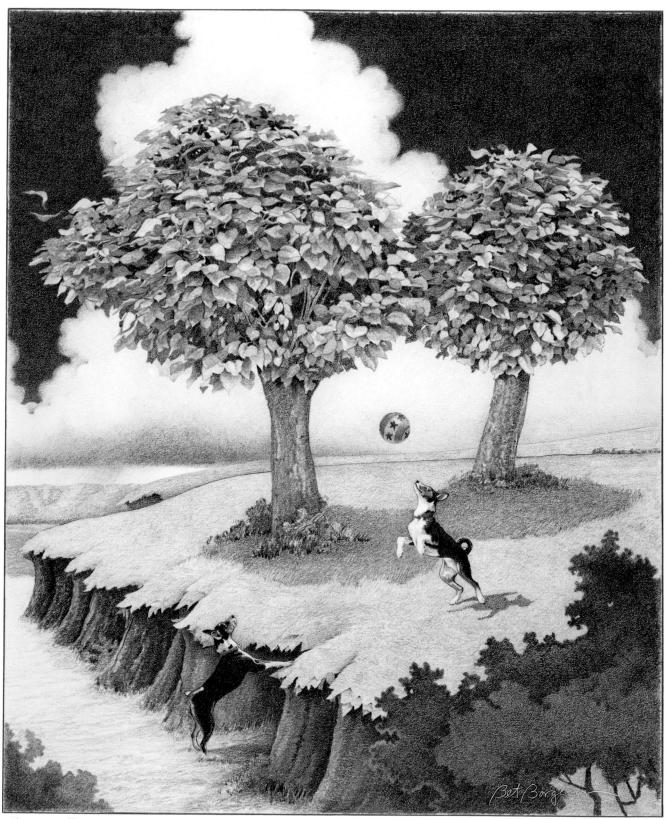

Showing Off
Colored pencil on two-ply Rising museum board,
19" × 15½". (48.3cm × 39.4cm)
Private collection.

INDEX

Acrylic, with colored pencil, 106-109 Activating gray, 73 Alayeral work, 29, 31, 32, 39, 42, 51 All prima, 42 Analogous colors, 26, 44, 46, 48 Art Stix, 15 background/large areas with, 62-69	Color(s) analogous, 26, 44, 46, 48 on colored paper, 104-105 complementary, 44, 46 delivering, 12, 18, 20-21 groupings, 44, 46-47 injected, 80-85 intensifying, 116 intensity, 70, 102, 116 juxtaposed, 44-51, 53, 72	Design marker, 113 Distressing technique, 92-95 Draft Horse and Madrones, 110 Drawing board, 15, 121 Drawing, studio tips, 112-123 Drawing surface(s) colored, 102-105 fast-working, 16-17 keeping clean, 121-122 soft, 40, 78	
Backgrounds/large areas	lifting, 54-59 lightfastness, 12	staining (imprimatura), 70 Dull colors, 44, 47	
with aqueous colors, 106-109 with broad stick colors, 62-69	low-intensity, 26, 29, 47, 70-72		
and imprimatura technique, 86-	modulation, 31, 32-33, 39 near-complementary, 26, 44, 46	Edges color spillover in, 77	
91 With injected color 90.95	palette	with graphite, 74	
with injected color, 80-85 with juxtaposed color, 44, 51	on colored paper, 104-105	and halo effect, 77	
and single-layer technique, 70-73	on white paper, 12	linear, 78-79	
and surface distressing tech-	temperature, 44, 47, 97, 99	working to, 74-79, 113	
nique, 92-95	value, 70	Equipment and tools, 12-17, 54,	
tip on, 116	adjustment of, 23 and colored paper, 102-105	112-123. See also Drawing surface(s); Paper; Pencil(s)	
and vignette, 100-101	quality of, 21	Erasers	
white, 96-99	wheel, 12	electric, 14	
Basic techniques	and white background, 96-97	kneaded, 14, 122	
and drawing surfaces, 16, 17 with heavy pressure, 24-25	Colored paper, 102-105	white plastic, 14	
with juxtaposed color, 44-51	Colored pencil drawing	Erasing	
and lifting color, 54-59	alayeral, 29, 31, 32, 39, 42, 51	impressed line, 114	
with spot-layering, 32-43	background in. See Back-	by lifting color, 54-59	
with tonal layering, 18-23	grounds/large areas	pigment dust, 121-122	
tools of, 12-15	components of, 124	preparatory to spraying, 122	
with two-layer approach, 26-31	drawing and delivering color in, 20	Fast working papers, 16-17	
using line with tone, 52-53	equipment and tools, 12-17, 54.	Fixative, spraying, 14, 116,	
Beauty, 32-33	See also Drawing surface(s);	122-123	
Bird of Paradise, 36-39	Paper; Pencils	Frisket film, 14	
Black colored pencil, 18, 23 Black paper, 102-103	hidden time traps in, 124	drawing negatively with, 54, 56,	
Blended spot-layering, 40-43	layering in. See Layering	58	
Blue Floral, 78	linear. See Linear drawing	lifting color with, 54-59	
Bold spot layering, 36-39	painted effect with, 17, 24-25		
Bright colors, 44, 47	portraiture, 40-43, 64-67	Good Girl, 63	
Broad stick colors, 62-69	and spontaneity, 54 tips on, 112-123	Graphite, 20-21 and single-layer technique, 70	
Burnishing tools, 14	two great paths of, 20	in transferring, 120	
with frisket film, 54-59	Colorless blender, 113	in working to edge, 74	
Canson Mi Teintes paper, 102-105	Complementary colors, 44, 46	Gray	
Cat and Poppies, 75	Composition	activated, 73	
Cat and Tulips, 28-31	and white backgrounds, 96-99	values and temperatures, 73	
Cat of Prosperity, 98	Cronaflex, 17	Grazing Belgians, 6	

Index

Halo effect, 77 Hero, 27 Hidden time traps, 124 Hobnail Vase, 8

Impressed line, 79 erasing, 114 signature, 112 Imprimatura technique, 86-91 Injected color, 80-85

Juxtaposed color, 44-51, 53, 72

Kate, 40-43

Large areas. See Backgrounds/ large areas Layering basic tonal, 18-23 with heavy pressure, 24-25 reasons for, 18 single-layer, 70-73 smoothing dark areas in, 115 spot-layering, 32-35 blended, 40-43 bold, 36-39 tonal, 18-23 two-layer, 26-31, 44 working to edge, 76 Lifting color, 54-59 Light box, window as, 119 Lighting work area, 15 Linear drawing edges, 78-79 with tone, 52-53 Low-intensity colors, 26, 29, 47, 70-72

Masking tape for lifting color, 54-56, 58 as paper reinforcement, 120 as pencil extender shim, 117 Mat board, colored, 102 Metallic color, silver, 29-30

Negative space. See Backgrounds/ large areas Night Bouquet II, 93 Nightsounds, 10 Nightwatcher, 60 Ornaments #2, 19

Painted effect, 17, 24-25 Palette on colored paper, 104-105 on white paper, 12 Paper colored, 102-105 fast-working, 16-17 temperature of, 97 See also Drawing surface(s) Pencil(s), 12 avoiding broken leads, 118 extending sharpening life of, 117 grips, 15 lengtheners, 15 lightfastness, 12 palette on colored paper, 104-105 on white paper, 12 point qualities, 12, 14, 18 pressure and color saturation, 16 creating wax texture with, and effect on paper texture, 20 heavy, 24-25 influencing net result, 18, and necessity of fixative, 123 preserving a line with, 78-79 sharpeners, 14 sharpening, 12, 14 on location, 119 See also Graphite; Prismacolor pencils Peony, 88-91 Polyester film, 17 Portraiture, 40-43, 64-67 Prismacolor Art Stix, 15, 62-69 Prismacolor pencils, 12 gray, 73

Quiet Game, 50-51

Rabbit and Flowers, 82-85 Rabbit and Studio Landscape, 81 Rabbits and Young Madrones, 49 Red Anjous and Baseball, 20-23 Rising museum board, 17 Sanctuary, 34-35 Sharpening, pencil, 12, 14 life, 117 on location, 119 Showing Off, 125 Signature, in dark surround, 112 Single-layer technique, 70-73 Smoothing, of dark areas, 115 Spot-layering, 32-35 blended, 40-43 bold, 36-39 Spraying fixative, 14, 116, 122-123 Stonehenge paper, 40, 65 Surface(s). See Drawing Surfaces; Paper Surface-distressing technique, 92-95

Temperatures of gray, 73
Textural change, 92-95
Tonal application 18-23, 86
Tone, linear drawing with, 52-53
Tracing paper
impressed line on, 79, 112
masking with, 116, 123
preliminary drawing on, 40
transferring with, 119-120
Transferring, 119-120
Travelers, 2
Two-layer approach, 26-31, 44

Utility brush, 121

Value, 70
adjustment of, 23
and colored paper, 102-105
of grays, 73
quality of, 21
Vignette, 100-101

Wax bloom, 14-15
White background, 96-99
White Floral, 17
White Floral #2, 53
White Floral #3, 99
White-pencil burnishing, 24-25
Window, as light box, 119
Workable fixative. See Fixative, spraying